POSTCARD HISTORY SERIES

Holliston

Stock images with a space to add a bit of local flair were popular during the early history of postcards; it is a tradition still enjoyed today. (Courtesy of Paul Guidi.)

ON THE FRONT COVER: Along Washington Street, free of trolleys and cars, a child waits with wagon and flag. (Courtesy of Dennis Cuddy.)

ON THE BACK COVER: On a quiet day in Holliston Square, trolleys pass each other, one heading north to Framingham and the other south to Milford. (Courtesy of Paul Guidi.)

POSTCARD HISTORY SERIES

Holliston

Dennis Cuddy, Paul Guidi, and Joanne Hulbert

ARCADIA
PUBLISHING

Published by Arcadia Publishing
Charleston, South Carolina

Printed in the United States of America

Library of Congress Control Number: 2013940029

For all general information contact Arcadia Publishing at:
Telephone 843-853-2070
Fax 843-853-0044
E-mail sales@arcadiapublishing.com
For customer service and orders:
Toll-Free 1-888-313-2665

Visit us on the Internet at www.arcadiapublishing.com

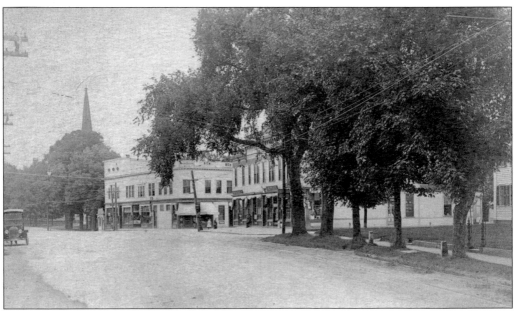

Holliston has yet to awake on this early morning. Only one car stands by, and a trolley has yet to appear. Holliston Square, the vibrant, bustling center of town, has always been where commerce, industry, and social activities begin in Holliston. (Courtesy of Dennis Cuddy.)

CONTENTS

ACKNOWLEDGMENTS

The images in this volume appear courtesy of authors Dennis Cuddy (DC) and Paul Guidi (PG).

INTRODUCTION

When Holliston saw the light of day on January 1, 1900, the trolley cars were running along Washington Street, and train service to Framingham, Milford, and points beyond was frequent and cheap. The first automobiles made their debut around the roads of the town, scaring the horses that still reigned supreme on the roads. George R. Russell took over Charles Morse's store on Central Street. Temperance was a big issue, and voters decided whether or not liquor should be sold in town. Andrew J. Cass kept an eye on the town treasury as if it were his own money, and much of it was. The warrant at the town meeting on March 5, 1900, contained 32 articles, including those amounting to $7,600 for the operation of the schools and $20 for the purchase of grave markers for the town's Revolutionary War soldiers. They also voted to pay each fireman $20 a year for his service. There were 559 students enrolled in the schools, and Holliston's population was hovering around 3,000.

The shoe shops still provided most employment, but straw hats were rapidly going out of style, so Mowry's factory on Elm Street was going bust. From the Andrews Block, burned in 1898, a new building rose out of the ashes with James F. Fiske's store still in its rightful place. Change was on the horizon, although no one could have imagined what would take place over the next 50 years. And yet, residents 50 years hence would see a square that looked very much like it did on January 1, 1900.

In eight years, Arthur A. Williams would become the major employer of shoe workers in Holliston, as the Goodwill Shoe Company would occupy the big shop on Water Street, allowing shoe manufacturing to hang on a few more decades before entirely disappearing. Most farms in Holliston in 1900 were gentlemen farms—the A.J. Cass farm and Louis E.P. Smith's Linda Vista, both on Phipps Hill, were owned by wealthy men, and Mary Cutler was still operating her produce farm on Highland Street.

Another transformation was happening in the early 20th century. Photography was becoming more accessible, and cameras were beginning to appear everywhere, with photographers taking pictures of people, buildings, landscapes, and current events. One way that photographs were easily distributed was by way of the postcard. Although Holliston is fortunate to have a reasonably abundant collection of pictures of our town before 1900, the camera was turned on subjects with wild abandon, and we are lucky to have had so many persons here who took up the art of photography. Results of their camera work ended up on postcards. Many persons also collected them, exchanged them with friends, sent them with messages about travel to and from Holliston, wrote notes on them about the well-being of family and friends, and sent them with whimsical notes to delight, inform, or enlighten. Today, the number of Holliston postcards available is a paltry few compared to the number available in 1900.

Herein are contained the extensive collections from two postcard enthusiasts. Both collections reflected the relative popularity of certain cards, especially those of the square, the Congregational church, and the Williams Shoe Company, as many more of those cards were actually used, mailed, and survived long enough to end up in collections. Many cards were never sent and were intended as souvenirs or traded with other collectors. Frequently, a sender asked the receiver to send along cards from far away if they had any. Photo finishers sometimes put the postcard imprint on the back of photographs, as store proprietor James F. Fiske did, just in case the owner opted to mail them. After all, a four-by-six-inch card is just the right size for a brief message sent on its way with a 1¢ stamp. Mail was delivered in Holliston twice a day, and one postcard might tell of the impending arrival of a friend in the afternoon, while another advised she had arrived home safely. A postcard sufficed for small matters of advertising or negotiation. In 1908, a young baseball player wrote the following to Earnest Carrol of Concord: "Dear Earnest, I think I can get up a nine. Are you fellows 10 to 15? How about the fares, will you fellows pay your own? We are broke. Where do you and Henry play? Write as soon as you get this and tell me about the fares. Are there big fellows on your team?"

Whether a Holliston-Concord game was played, we may never know. What we do know from the Holliston postcards is the square was timeless in its history and appearance. We know that the big shop on Water Street without Goodwill Shoe Company is still a center of innovation and industry. We know that the train depot on Railroad Street is still a central gathering place for our townspeople despite the disappearance of the trains; with burgers, beer, and the Sox on the big screen, Casey's Crossing is the best ticket in town. We know that Quincy Place has not changed since the days of Thomas Andrews and Sam Carr, and that writer Ellen Biscoe would still be able to use this neighborhood seemingly frozen in time as background for her stories if writing today. Phipps Hill remains a challenge for travelers. With trolley cars no longer inching uphill and then catapulting down the hill, cars make the crawl uphill toward the traffic light today. Lake Winthrop still has three islands, Valentine's Rock, and two beaches, and the only change seems to be the bathing attire. The Winthrop Canoe Club is gone from the north shore, but canoes still set off from the shores of Wennakeening as they have for time immemorial. The railroad tunnel under Highland Street, despite no trains passing through, can still send out a boisterous echo if voice or trumpet is used to conjure up a dizzying round of sound waves.

A few places have disappeared. The woolen mill fire at Mill Pond in 1933 ended nearly three centuries of industrial history on that site. The Great Hurricane of 1938 destroyed the old Baptist church, and the post office, no longer on Central Street, relocated halfway to Milford on Washington Street. The Washington elms succumbed to traffic trauma or Dutch elm disease. Breezy Meadows Camp and the Orchard House of Myer Gotz were both replaced by other recreation.

And yet, old gives way to new, as George W. Slocum passed on the love of antiques and the thrill of the hunt, as several shops in Holliston now welcome a new generation of treasure hunters. The trains have given way to bicycles and feet on the old railroad bed, and the Methodist church is now the Masonic lodge. The old wooden schoolhouses are gone or converted to housing units. The churches and town hall, once painted in an array of colors, are now painted white or a timid gray. Otis W. Gassett, purveyor of Chase and Sanborn coffee in 1902, can buy his favorite brand of coffee today at the Superette, and Mary Cutler would find all her plants and produce at Arcadian Farm on Norfolk Street. Despite all the changes in Holliston over the past century, if George, Otis, and Mary were to time travel to present-day Holliston—or if we were to travel back to their time—we could all in unison say, "Pretty familiar looking place, isn't it?"

One

THE SQUARE

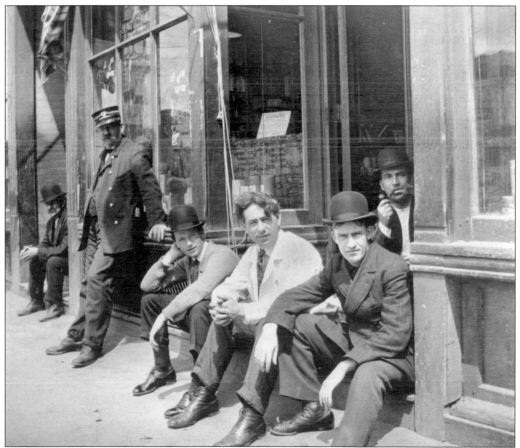

John Sheedy, Dennis J. Curran, Andrew B. Curran, James H. Crowley, William J. Hayes (also known as Brownie), and Fred Griffin, all proud residents from Mudville, enjoy the noonday sun on the steps of the Holliston Pharmacy at Pond's Block, later known as Forbes Block. This leisure activity is still enjoyed by residents today who visit Holliston Jewelers and the Holliston Grill (Pete's). (DC.)

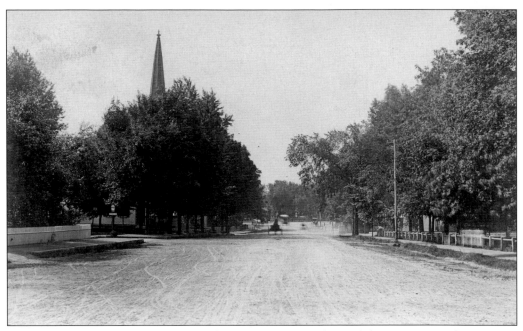

Only the road surface and the Baptist church steeple have changed the streetscape of today. The approach to Holliston Square looks the same. This photograph, taken before 1895, the year the trolley tracks appeared, shows a street much traveled then as it is still today. (DC.)

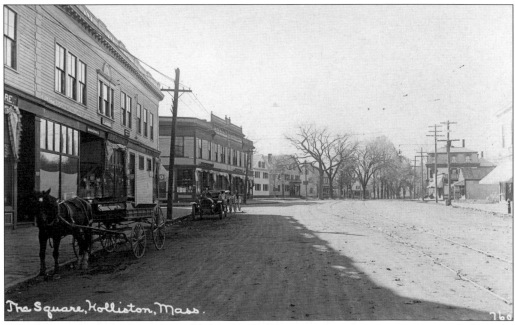

The changing times were noticeable in the different modes of transportation with first the horse and wagon, then the trolley tracks wending their way through the square, and finally, the newfangled horseless carriage, which was increasing in popularity. (PG.)

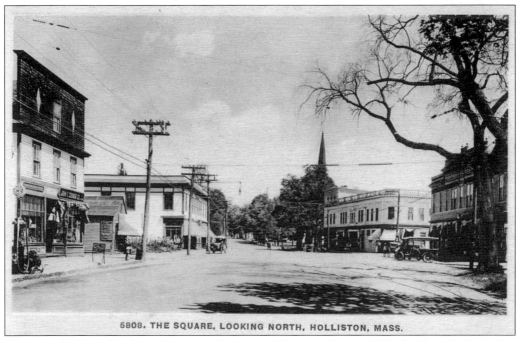

5808. THE SQUARE, LOOKING NORTH, HOLLISTON, MASS.

The main business blocks on the square have stood the test of time, all having been built before 1900. Only the old building that once housed Gilmore's Store and a barbershop has been replaced today by the Mobil gas station. (PG.)

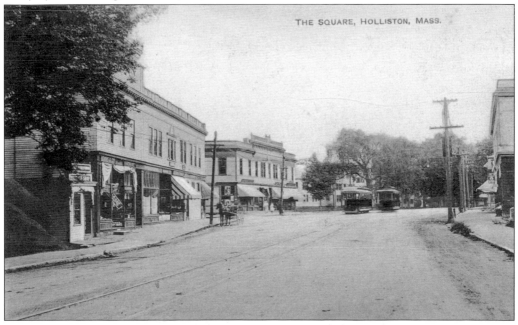

THE SQUARE, HOLLISTON, MASS.

There were proponents for the trolley line, which was established in 1896, but there were also several who thought it would compete unfairly with the train that ran along nearly the same route. But Holliston residents were thrilled with all the local stops from Framingham to Milford that cost only 5¢ if one got off at Baker Street, 10¢ if one rode all the way to the square, and 15¢ if one went all the way to Milford. (PG.)

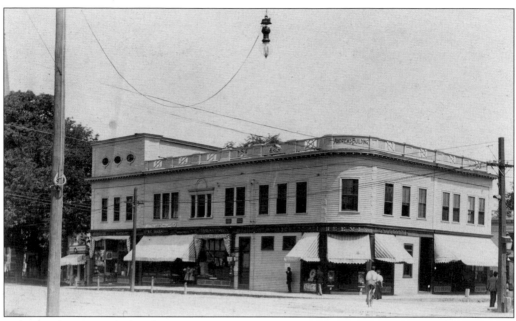

In December 1898, the brick Victorian-style Andrews Building burned and was replaced by the present-day business block, the home of Fiske's General Store. Fiske's has been at this location since 1863. This building was the site of the first plate-glass window in Holliston. (PG.)

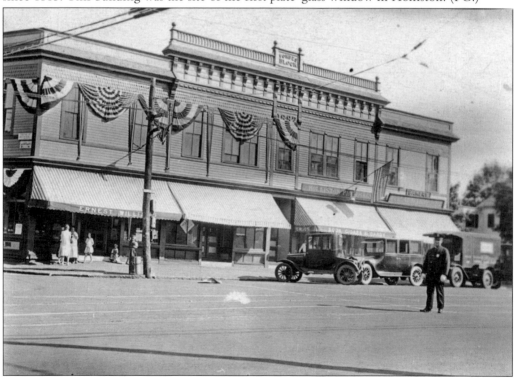

The building that occupies the square from Central Street to Exchange Street has borne the names of previous owners, like Pond and Forbes. Pete Ferrelli, the current owner of the block, is often seen holding court on the bench outside and is always ready to converse with passersby. (DC.)

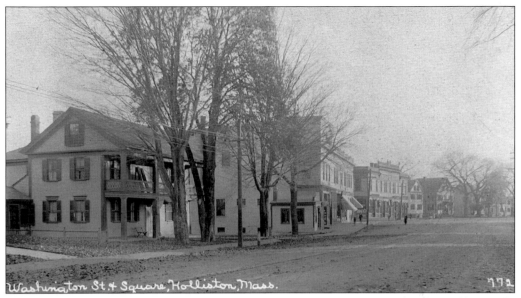

Washington St. & Square, Holliston, Mass.

The quiet of early morning pervades the square in this c. 1900 photograph. The trolley tracks are in place, and the Andrews Block appears as it did when it was built in 1899. Today, it remains the home of Fiske's General Store. (PG.)

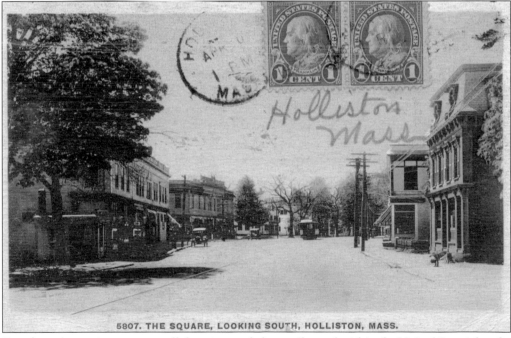

5807. THE SQUARE, LOOKING SOUTH, HOLLISTON, MASS.

For a long time, a 1¢ stamp was all that was needed to mail a card within the United States, but for foreign deliveries, two stamps were needed, as this card mailed to Arthur Krebs in Falkenheim, Germany, by Holliston resident N. Leroy Carpenter, depicts. He wrote the following: "Dear Sir, From International Stamp Market Note Exchange. I desire only best class views, street scenes, people, historical, 1 to 10 as desired. Will give best in exchange as desired." But, alas, the postcard was returned as *unbekannt*, which translates to "unknown," and so, Carpenter had to search for collectible postcards elsewhere. (PG.)

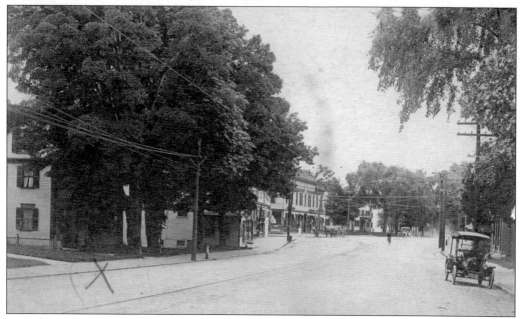

The letter "X" marks the spot of the Holliston Historical Society, a landmark in the square until 1974. The former home of Dr. Sewall G. Burnap, the house was torn down to make way for more commercial space near the other business blocks. (PG.)

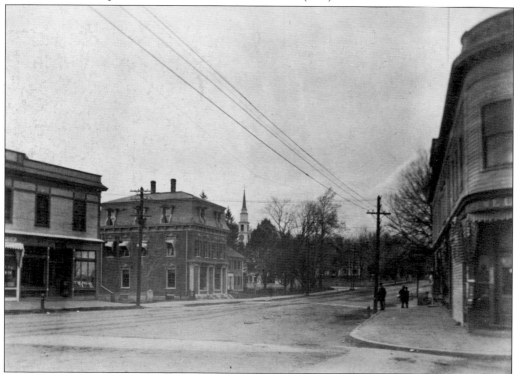

Here, a few people are perhaps waiting for the arrival of the trolley on a morning that appears bleak and cold. Across the street is Talbot's Block, and the future location of the Holliston Superette can be easily imagined. (PG.)

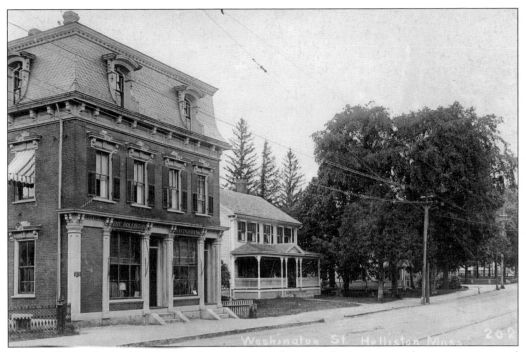

The Holliston Savings Bank, in all its proud stodginess, glorious strength of character, and fiduciary confidence, has graced the square since just after the Civil War. Only once, in 1931, was it the scene of a bank robbery. (DC.)

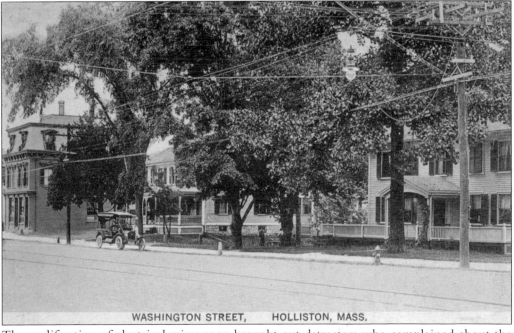

WASHINGTON STREET, HOLLISTON, MASS.

The proliferation of electrical wires soon brought out detractors who complained about the "untidy appearance" of the street scene around the square. Seen here are the wires for the houses and businesses and the wires that supplied the street railway trolleys. Automobiles began to make their appearance shortly after 1900. (PG.)

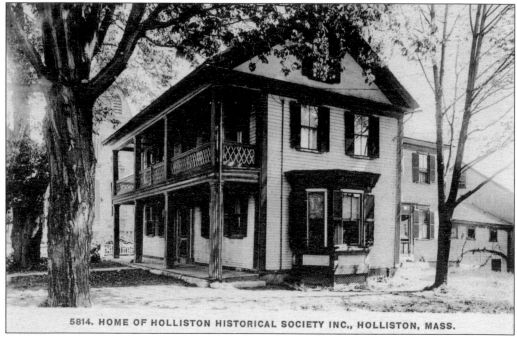

5814. HOME OF HOLLISTON HISTORICAL SOCIETY INC., HOLLISTON, MASS.

Across Washington Street stood the home of Dr. Sewall Burnap. At one time, the building housed the post office. It eventually became the home of the Holliston Historical Society. The society moved from here in 1974, and Al's Restaurant subsequently occupied the building. The house was eventually torn down to make way for a new commercial building. (PG.)

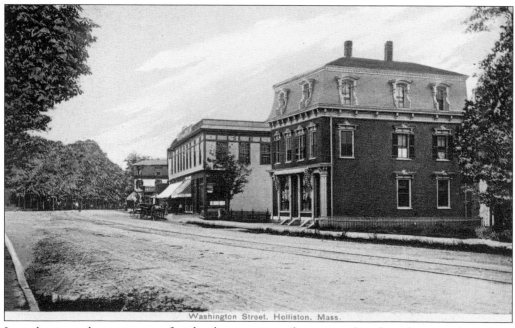

Washington Street, Holliston, Mass.

In order to make a more perfect landscape scene, the postcard maker eliminated all those bothersome electrical wires, creating a pristine, uncluttered view. But how else could the trolleys have navigated those tracks through the square? (DC.)

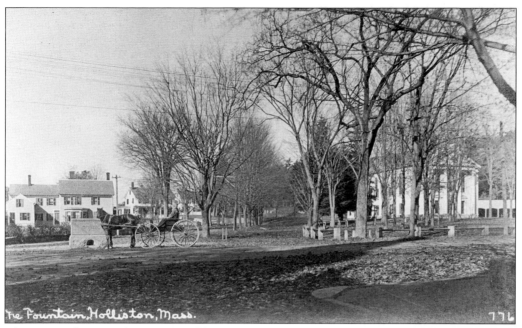

The granite fountain that once stood in the middle of the intersection of Washington and Hollis Streets was not, as some have presumed, a horse trough, despite the patron standing by. The fountain, there for humans, was placed in conjunction with the new waterworks constructed in 1891. (PG.)

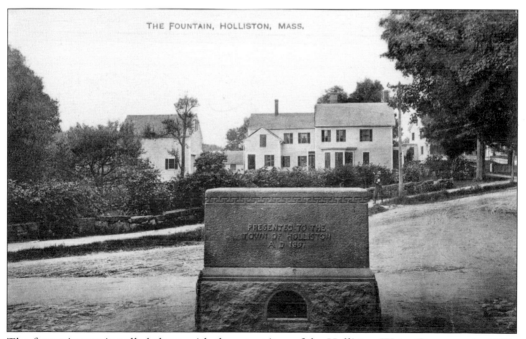

The fountain was installed along with the new pipes of the Holliston Water Company in 1891. The privately owned water company offered to supply water to the fountain free of charge on the condition that the town would pay for the water supplied to the fire hydrants. (PG.)

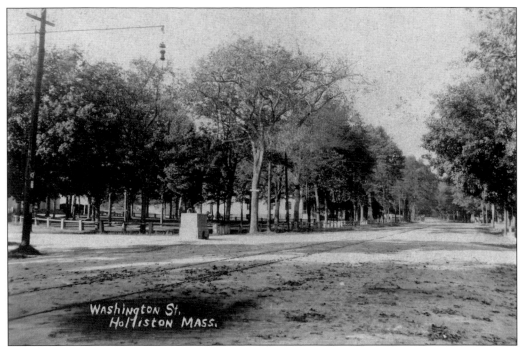

How many times have Holliston's automobiles maneuvered their way through the intersection at Washington and Hollis Streets? Luckily, present-day drivers do not encounter the fountain that once stood there; it was removed due to increased car traffic, and it was a good thing that it was—for both the cars and the fountain. (PG.)

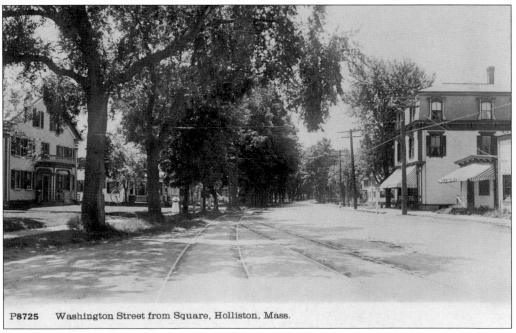

P8725 Washington Street from Square, Holliston, Mass.

The way southwest from the square by foot, wagon, trolley, or car has looked the same since the road was first laid out when the town was incorporated in 1724. The street has a slight curve as it sets out toward Phipps Hill and beyond to Milford. (PG.)

18

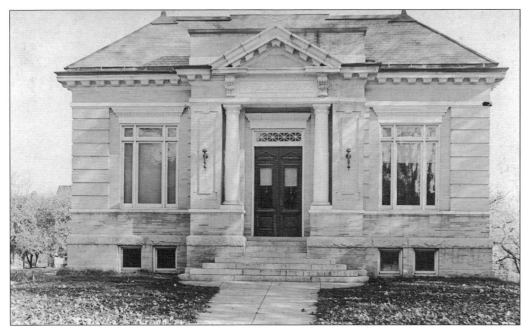

In 1903, Holliston moved the public library from a room at the town hall to a new building near the square. The Holliston Public Library was built according to "the Carnegie Formula," which required the town's need for the new library building, a site designated for it by the town, and a 10-percent annual financial commitment before the Carnegie infusion of funds were given. And, of course, the library must be free to all. Beneath one of the pillars by the front door, a time capsule containing information of interest in 1903 was placed. The specific pillar was not revealed. (DC.)

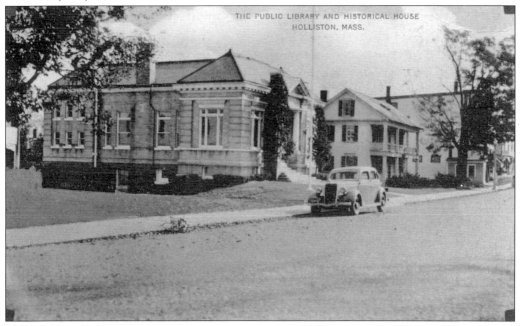

The Holliston Public Library found a permanent home in 1903 with a gift of $10,000 from Andrew Carnegie and with substantial contributions from the townspeople of Holliston. (DC.)

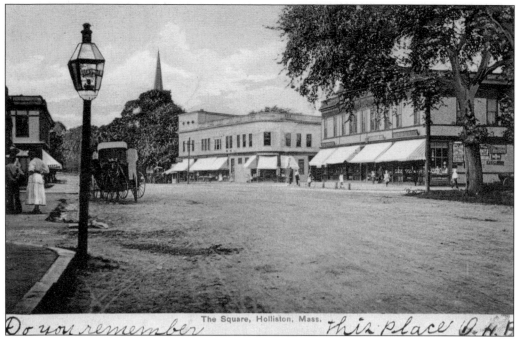

The Square, Holliston, Mass.

Do you remember *this place C. H. B*

"Pretty familiar place, isn't it?," wrote a friend to Florence Gates. "Glad to hear that you like your work so well. I too am kept pretty busy and hardly have a chance to go to see the town. I was up to Millis and gave my first lesson in parlez-vous German! Hoping to hear from you soon. Jeannette." (PG.)

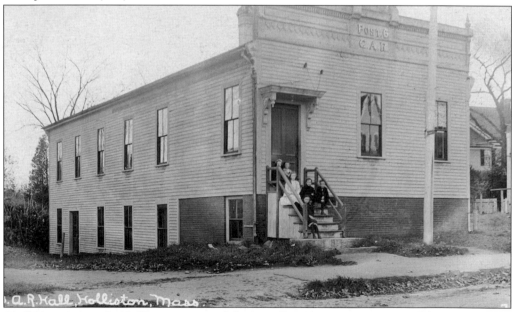

G. A. R. Hall, Holliston, Mass.

Civil War veterans in Holliston organized the Powell T. Wyman Post No. 6 of the Grand Army of the Republic (GAR) on March 6, 1867, and it was one of the first 10 posts organized by the Department of Massachusetts, GAR. In 1878, their house was the first built and owned by a local post in Massachusetts. Today, the building is the home of the Holliston Animal Hospital on Exchange Street. (DC.)

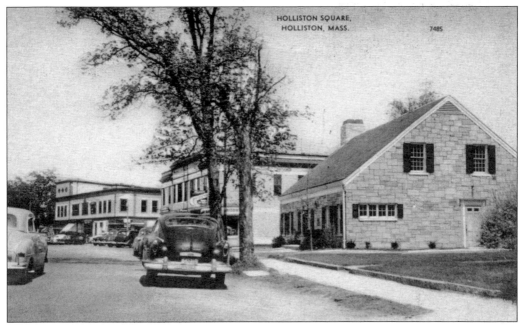

In the 1950s, the traffic on Washington Street increased to a frenetic pace. The newly built Framingham Trust Company, now home of the Santander Bank, replaced an old house that once stood there at the corner of Exchange Street. (DC.)

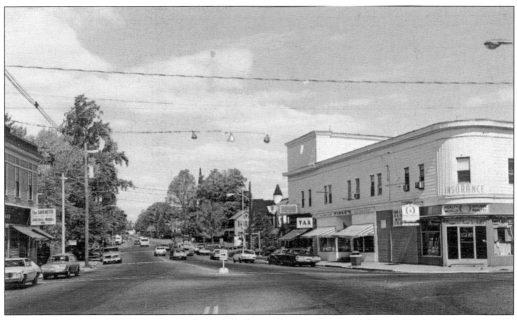

Despite the inevitable changes each decade brought, the square still retains its quintessential small-town character, and vestiges of a century past are still visible in this postcard from 1978. (DC.)

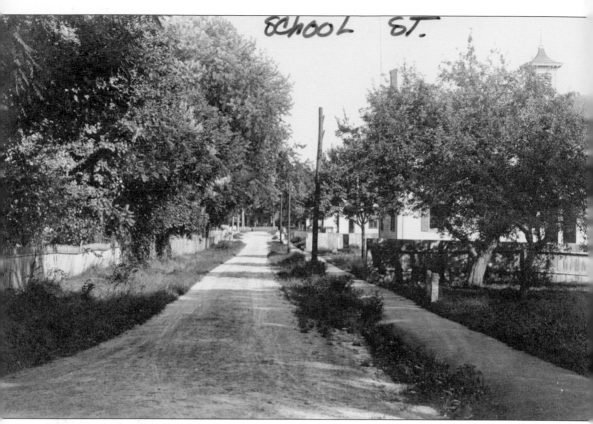

There are virtually no postcards that take in the sights and scenes of Mudville in Holliston. Perhaps the shady reputation of its early history as the home to illegal kitchen bars and Saturday night card games, and not the shady trees, was the cause of the oversight by early photographers. In this rare view of School Street, a hint of the true character of the neighborhood reveals one of Holliston's best-kept secrets—there is joy in Mudville. (DC.)

Two

PUBLIC BUILDINGS

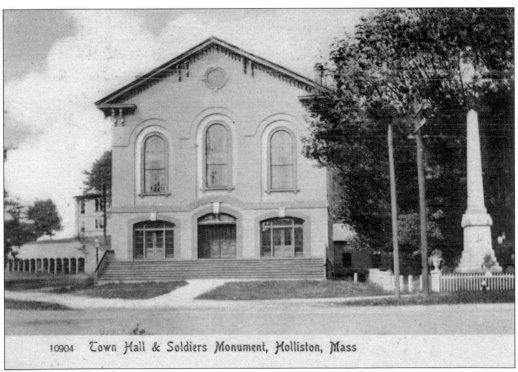

10904 Town Hall & Soldiers Monument, Holliston, Mass

The image of the town hall was among the most popular postcards. Town hall was the most recognizable building in Holliston. In 1854, practical architect and builder Edwin Payson submitted his proposal for the "New Town House" to be constructed "upon a lot of land known as the 'Old Town House Lot,'" near the location of an old meetinghouse that had become obsolete. (DC.)

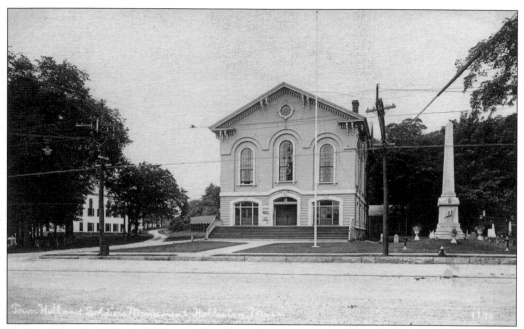

Payson described the building to be of wood construction and of the "Modern Order of Architecture." Measurements were 90 feet in length, 53 feet in width, and two stories in height, with the first story 12 feet, 4 inches high, and the second story, or hall story, 25 feet high. An elegant circular staircase led to a third story, reserved as an armory, under the sloping roof. (DC.)

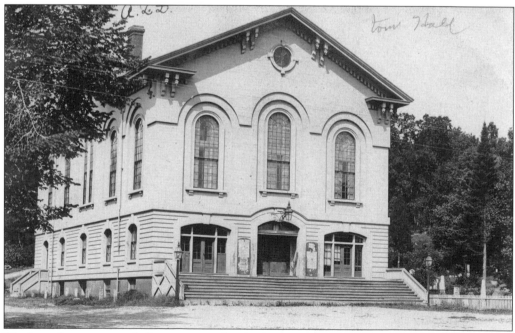

Work on the new town hall was expected to be fully completed on or before October 25, 1855. Construction went smoothly, encountering only minor delays, such as when a few unmarked graves were found when the foundation was dug. The project was finished on time. (DC.)

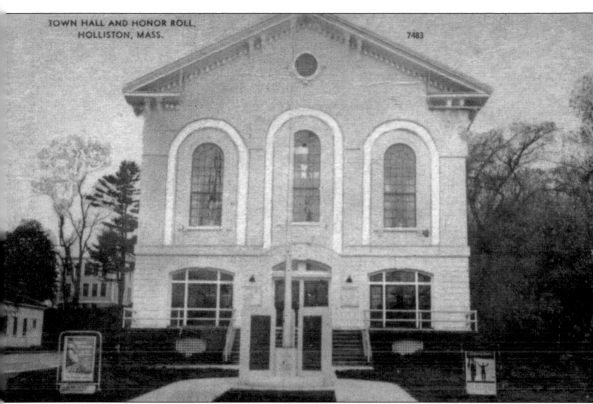

TOWN HALL AND HONOR ROLL,
HOLLISTON, MASS.

7483

A more recent photograph of town hall in the 1950s shows the military honor roll out in front. For many years, the debate over whether the building should be painted white or another color inspired debate. Today, town hall is painted gray and white. The original paint in 1855 included three heavy coats of white lead and linseed oil with white beach sand added to the second coat. Even then, the color was open to debate, and the final decision was left up to the building committee. They did not always choose white. (PG.)

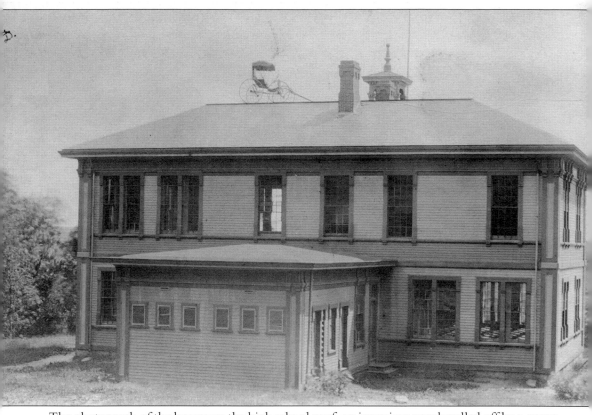

The photograph of the buggy on the high school roof, an ingenious prank pulled off by a group of enterprising students, was so iconic that it became a popular postcard exchanged by students obviously proud of their handiwork. Adults, including the buggy's owner, astonished at the accomplishment, allowed the deed to go unpunished. (DC.)

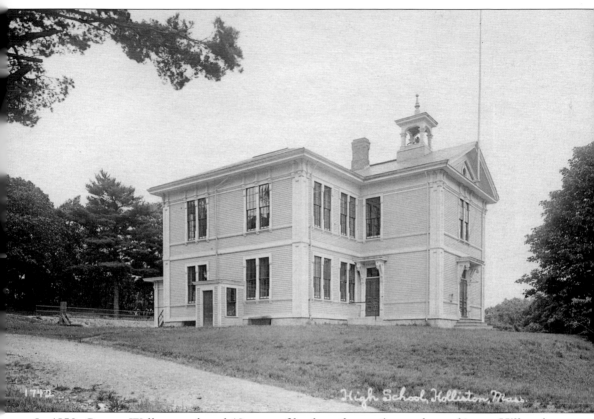

In 1850, George Walker purchased 10 acres of land on the southwest slope of Jasper Hill and erected a school building, known as Mount Hollis Seminary. The building was acquired in 1865 by the Town of Holliston to be outfitted as the first town operated high school. The building burned in 1871, and the town rebuilt a new school in 1874 at a cost "not to exceed $10,000 for foundation and all." The new high school, named the Walker School, honored Holliston's early educator. (DC.)

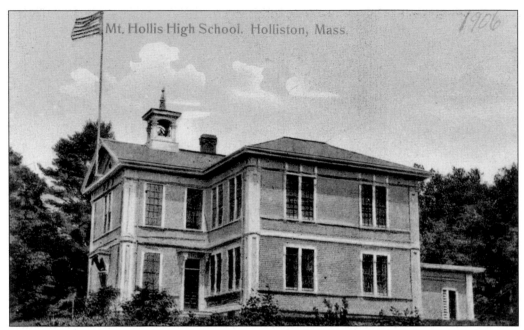

Besides being known as the Walker School, or Holliston High School, it was also referred to Mount Hollis High School, a tribute to the old Mount Hollis Seminary that once occupied the same spot. The school did commendable work as the town's high school until 1957, when a new building was constructed on Woodland Street. (DC.)

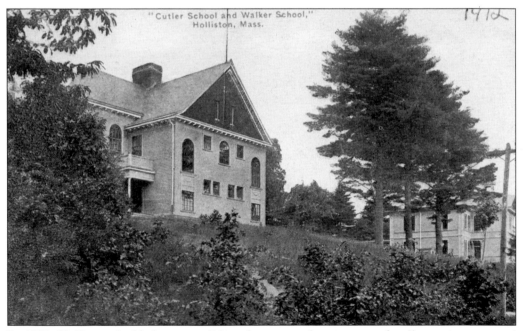

In 1891, Holliston decided to consolidate the scattered one-room schoolhouse in town and brought the students together at the Cutler School, named in honor of Elbridge Jefferson Cutler, a writer, teacher, and native son. Originally, the building contained four classrooms but was quickly increased to eight rooms when a brick addition was added to the front of the structure. (DC.)

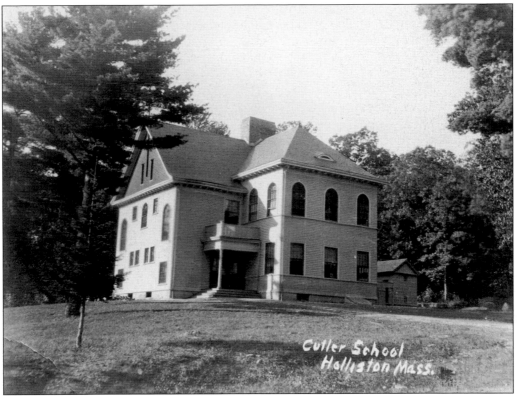

For those Holliston students who spent a year or two in the Cutler School, with the tall windows, the creaking wooden floor, the slate blackboards, and the quaintly primitive lavatories that replaced the outhouse seen in this picture, there is something that strikes every alumnus nostalgic about the old place. How quickly the picture of this old building conjures up vivid memories. (PG.)

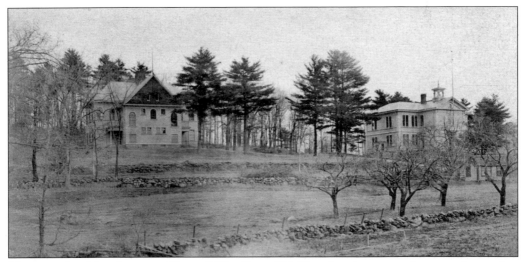

The two schools on the slope of Jasper Hill reflected Holliston's serious commitment to improving education for all the children and produced generations of young people ready to join the working world or pursue higher education. The commitment to ensuring educational excellence is still the major goal of the Town of Holliston. (DC.)

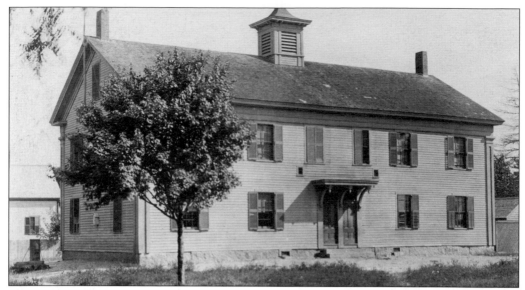

Schoolhouse No. 8 on School Street was the educational mecca of the Irish immigrants who resided in Mudville. Since many of the immigrants were denied education back in the old country, the value they placed on the schoolhouse in their midst was marvelous. In 1856, the residents of Mudville campaigned at a town meeting to have the high school classes moved to their school, but their detractors would not stand for having them housed in Mudville. The high school was temporarily placed in town hall instead. The school would eventually be known as Andrews School. (DC.)

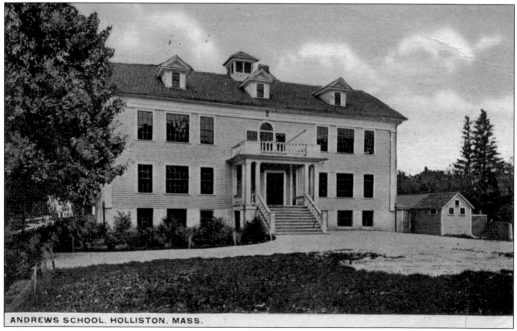

ANDREWS SCHOOL, HOLLISTON, MASS.

The second school on the site of old Schoolhouse No. 8 was built in 1913 and was intended to improve the facility and be a better environment for learning. The rooms were larger, and the problems with proper ventilation were addressed. The outhouses for the students' convenience were still the way to go in 1913. (DC.)

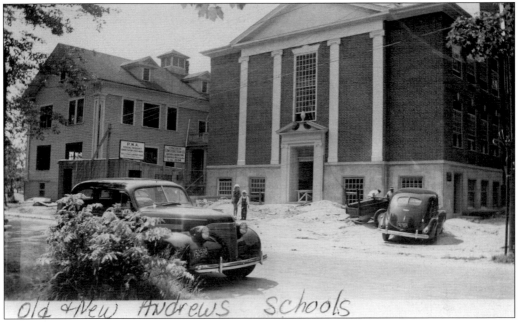

Old & New Andrews Schools

The third Andrews School was constructed thanks to the Works Progress Administration during the Great Depression. The building housed a school until 1999 but has since been unoccupied and forlorn. A new use for the building is an ongoing debate. (DC.)

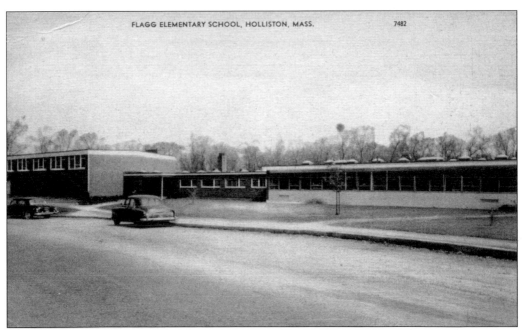

FLAGG ELEMENTARY SCHOOL, HOLLISTON, MASS. 7482

Flagg School was constructed in 1955 and was the first new school building in more than 20 years. A new style of building heralded significant changes in how education was delivered in Holliston. Today, the building is utilized as office space and storage, and it also spent time as the temporary quarters of the police department during construction of its new facility on Washington Street. (PG.)

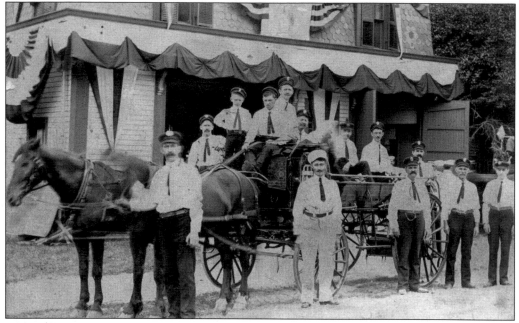

The Holliston Fire Department maintained a station on Central Street on the east-side bank of the brook. Originally, the hooks and ladders were kept there before the steamers arrived in 1871, heralding a new age in firefighting in Holliston. (PG.)

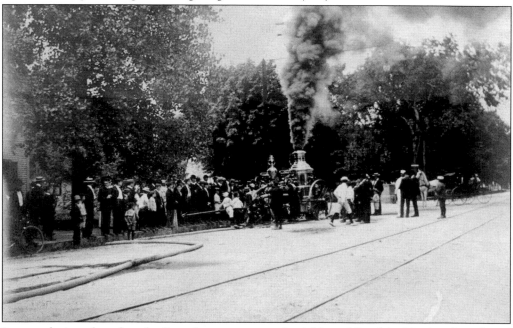

It was a glorious day when the first of two steamers arrived. Named Excelsior No. 1 and purchased for $3,500, a fortune by town treasury standards, the apparatus, a "Silsby steam fire engine of the third size," was manned by 44 men, nearly the number of all the Holliston firefighters today. The steamer heralded a new era in firefighting in Holliston; it was a time when a higher level of technical knowledge was required, as a steamer could be dangerous. If the boiler did not retain water, the reservoir could explode. (DC.)

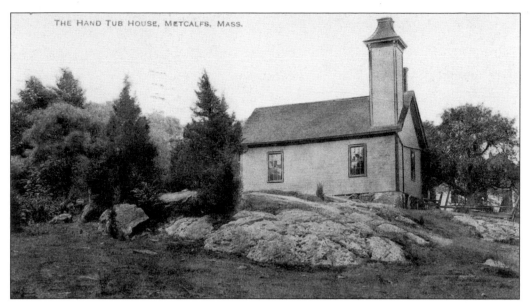

THE HAND TUB HOUSE, METCALFS, MASS.

One of the old firehouses was maintained due to its remote location. The hand tub house at Metcalf Station, which still stands near the corner of Washington Street and Summer Street, housed the old hand tub that was purchased in 1867. On April 1, 1899, the fire engineers discontinued the services of the men who cared for the hand tub at Metcalf, removed the telephone from the building, and left that part of Holliston to look after itself as best it may as far as local fire protection was concerned. (DC.)

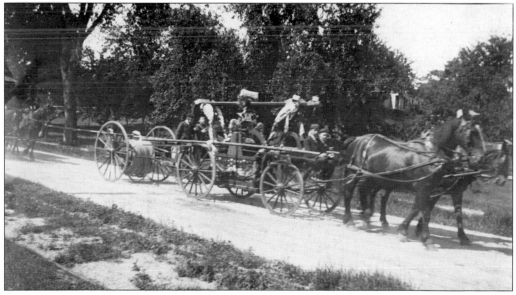

The old hand tub, known as Hydrant No. 3, was a venerable piece of fire apparatus. Purchased in 1867, it was a Hunneman engine and was manned by a team of 30 men. Tradition tells the story that the tub was purchased from a group of Harvard College students who had previously registered their disgust with the machine and tossed it into Boston Harbor after a particularly poor showing at a fire muster. When Holliston inquired about purchasing it, they fished it out of the harbor, dried it off, and sold it to the town. It served the town as well as it could for the next three decades. (DC.)

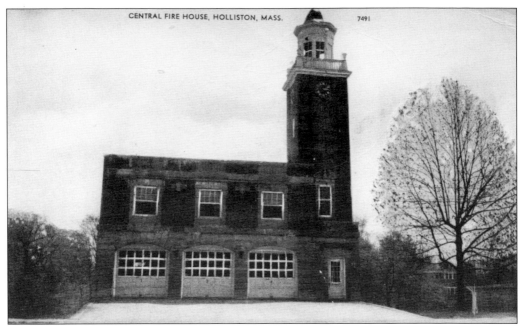

With advancements in firefighting demanding larger and more complex apparatus, Holliston constructed a new fire station in 1930 at a cost of $11,551. The three bays would now accommodate trucks that had a difficult time fitting into the old station diagonally across the brook on Central Street. There would not be a need to expand the building for another six decades. The tower was used for drying hose and housed the air horn that alerted all to an alarm of fire and to the noonday hour. (DC.)

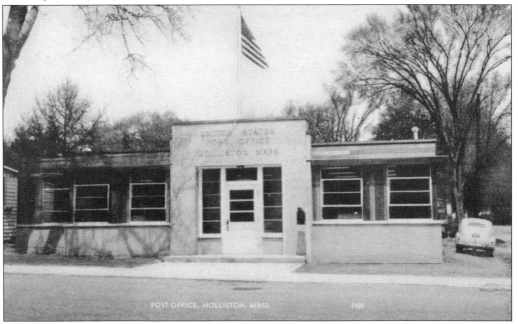

Although the post office is now located two miles beyond the square, it once was on Central Street across from the fire station. The building is now home to the Holliston True Value Hardware Store. (DC.)

Three

ALL AROUND THE TOWN

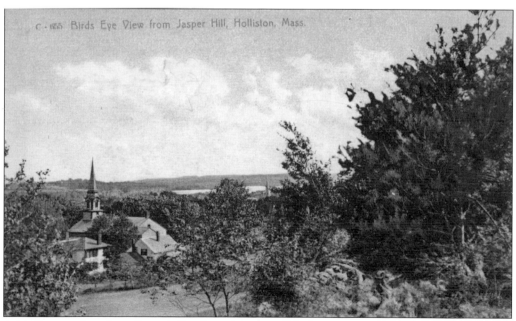

c - 1855 Birds Eye View from Jasper Hill, Holliston, Mass.

A bird's-eye view from Jasper's Rock on Jasper Hill before 1900 afforded a glimpse of Lake Winthrop in the distance and the Methodist church in the foreground. (PG.)

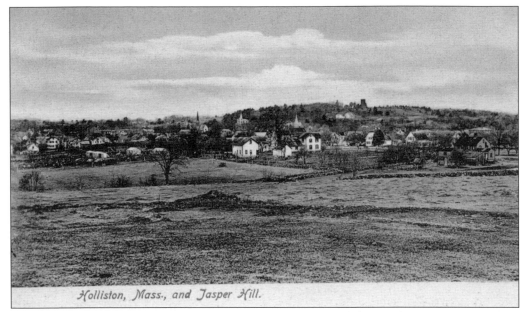

Holliston, Mass., and Jasper Hill.

Cleared fields, the cluster of houses around the town center, and the standpipe on Jasper Hill are what can been seen from a vantage point near present-day Arcadian Farms on Norfolk Street. Today, a dense cover of trees obscures the view. (DC.)

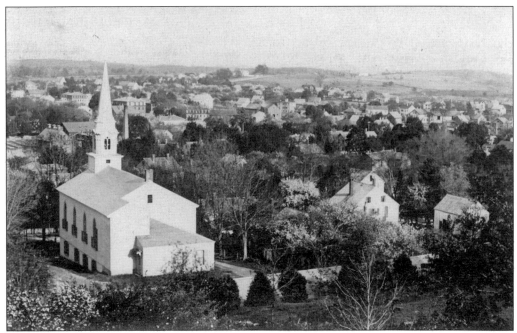

Jasper Hill was a popular location for photographs of Holliston. The Methodist church in the foreground, now the Masonic hall, still had its steeple that was ultimately destroyed by the Hurricane of 1938. (DC.)

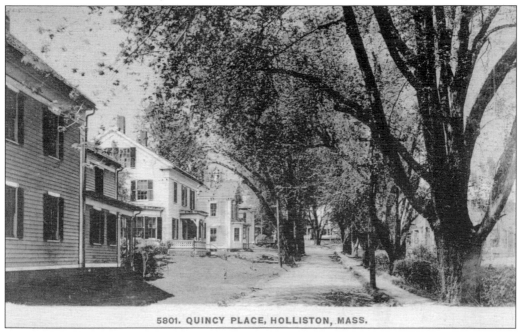

5801. QUINCY PLACE, HOLLISTON, MASS.

On one of the loveliest streets in Holliston, the stately homes and the towering shade trees are still there. The view and the atmosphere have barely changed in more than 100 years. (DC.)

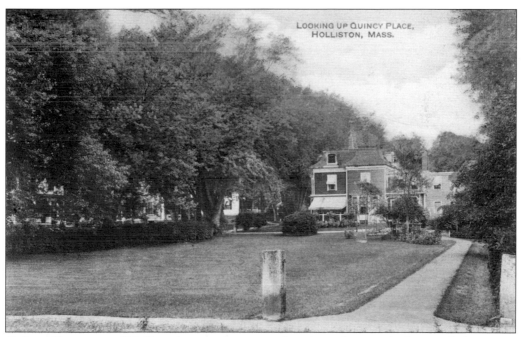

LOOKING UP QUINCY PLACE, HOLLISTON, MASS.

Quincy Place, one of Holliston's most picturesque locations, features the home of Thomas E. Andrews (1822–1903), selectman, town treasurer, collector of taxes, and trustee of the public library. Andrews earned local fame and fortune as a seller of straw hats. He went on to greater fortune in real estate speculation and as owner of the Andrews Block that once stood at the corner of Washington and Central Streets. (PG.)

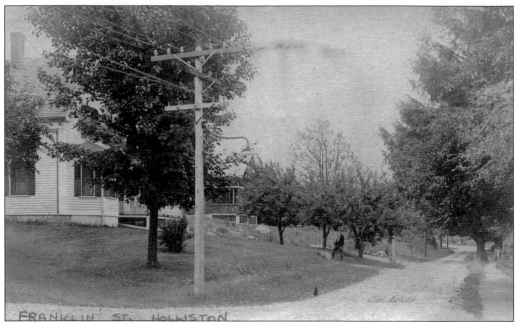

FRANKLIN ST. HOLLISTON

Franklin Street connects Central Street to Norfolk Street and is one of the major thoroughfares in the neighborhood known as Ward Four, which is home to several shoe shops, stately homes, and the old Schoolhouse No. 4. Today, the street has become a handy shortcut between the two major routes to Millis and Medway. (PG.)

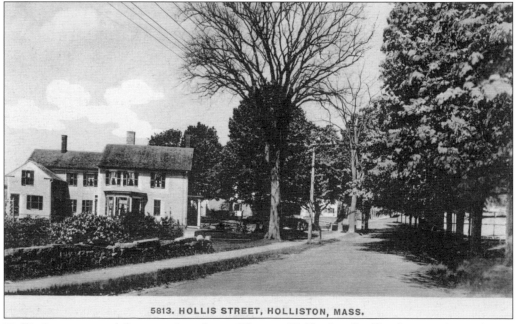

5813. HOLLIS STREET, HOLLISTON, MASS.

Hollis Street, named for town benefactor Thomas Hollis, is a familiar intersection today to travelers heading to Holliston High School, or to Hopkinton and points west. The home at left was the James F. Fiske home and claims fame as one of the first equipped with a telephone in 1878—with a line that reached from the house to Fiske's store in the Andrews Block in the square. (PG.)

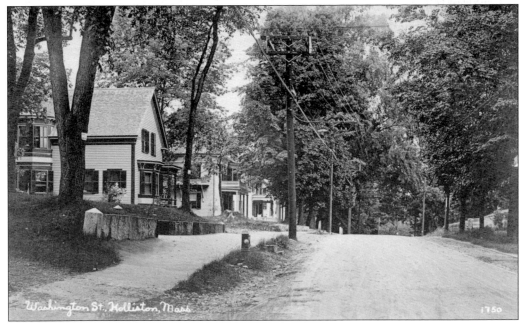

Washington St. Holliston, Mass. 1750

Along Washington Street, electric and telephone lines grew substantially during the last two decades of the 19th century. With the addition of the trolley lines on the right, the town was becoming connected to the outside world. The photograph was taken about 1900 looking northeast from in front of the Methodist church. (PG.)

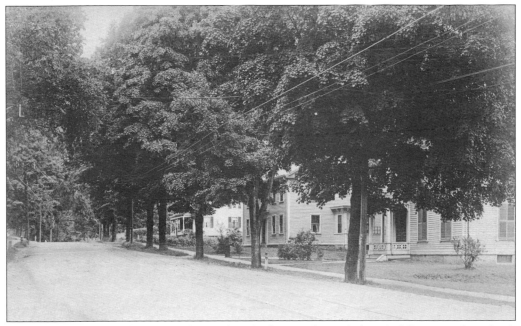

Across the street, also facing northeast, the telephone poles and electrical lines ran along both sides of the street. Comments began to emerge complaining about the tangle of wires that were often damaged by the trees that also vied for space along Washington Street. (PG.)

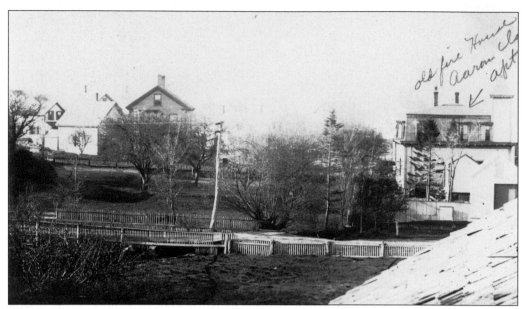

From a rooftop on Church Street, the view toward Charles Street in the foreground catches a glimpse of the old firehouse on Central Street. (DC.)

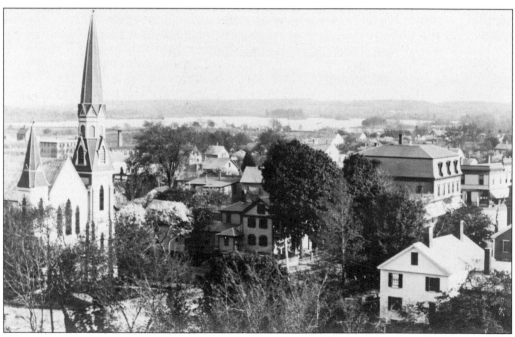

From the steeple of the Congregational church, the view all the way to Lake Winthrop and beyond takes in part of the square, the Baptist church diagonally cross Washington Street, and the Andrews Block and its mansard roof reigning supreme. The photograph was taken before 1898, as the fire that destroyed the Andrews Block changed the scene dramatically, as did the Hurricane of 1938 that destroyed the Baptist church. (DC.)

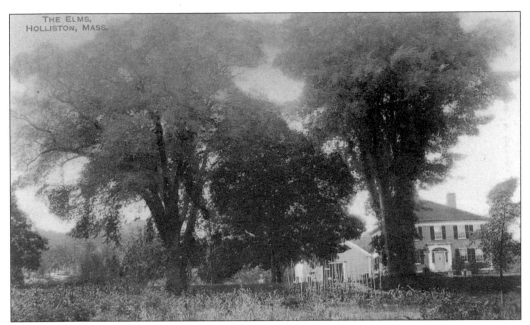

The great elms of Holliston have all disappeared, victims of Dutch elm disease. Once admired by many famous visitors from George Washington to William Howard Taft, the trees survived harsh winters and intrusion from trolleys and cars. The house in the background has not disappeared. The current home of the Holliston Historical Society remains today as one of the town's most enduring landmarks. The Holliston Police Station now occupies the location where the elms once stood. (DC.)

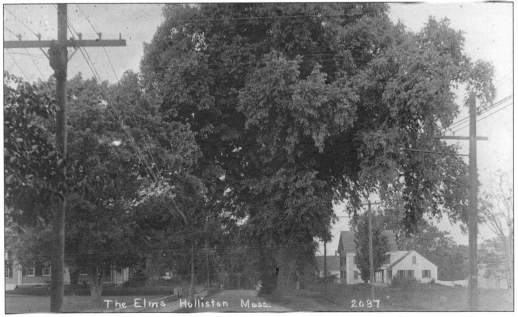

The Elms Holliston Mass. 2037

Trolleys are to the right; cars are to the left! The elms along Washington Street were witness to the changes that literally surrounded them from the seedlings they were in the 18th century, to the majestic canopy of the 20th century. Located near the present location of the police station, the last tree succumbed in 1944. (PG.)

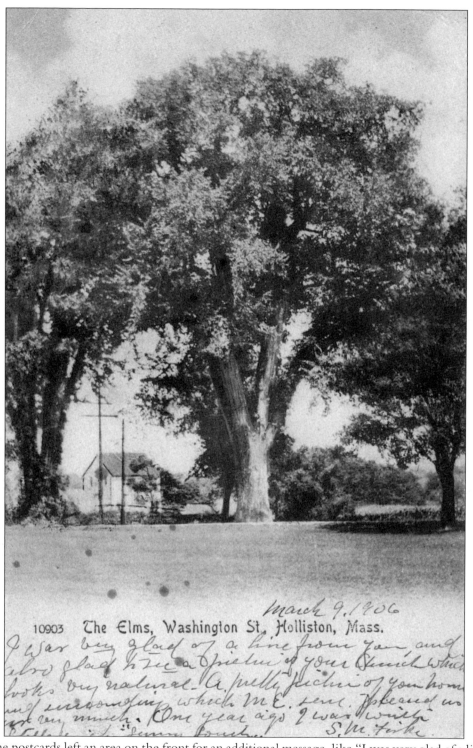

Some postcards left an area on the front for an additional message, like "I was very glad of a line from you." S.M. Fiske took advantage of this space in 1906. Usually, all blank spaces were used to write messages, and sometimes, messages were even scrawled across the pictures. (DC.)

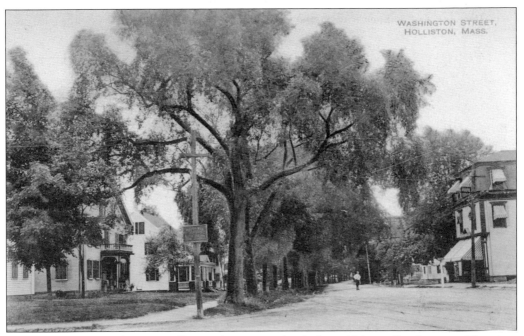

Visitors and new residents to Holliston always mention its beautiful tree-lined streets. The view from the square looking westward along Washington Street at the corner of Exchange Street is still familiar today. (PG.)

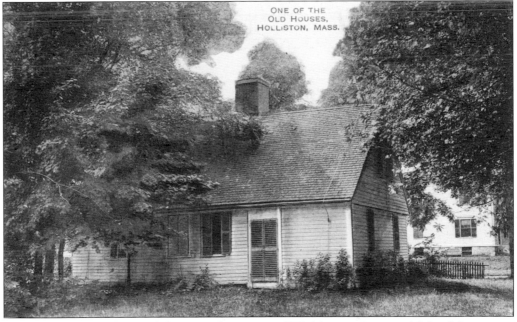

ONE OF THE
OLD HOUSES,
HOLLISTON, MASS.

The picture of the old Marsh home at the corner of Washington Street and School Street was a popular postcard as it reflected the romantically quaint homes in Holliston. Few of these older abodes survived, as these houses were often torn down to make way for larger, modern homes. (DC.)

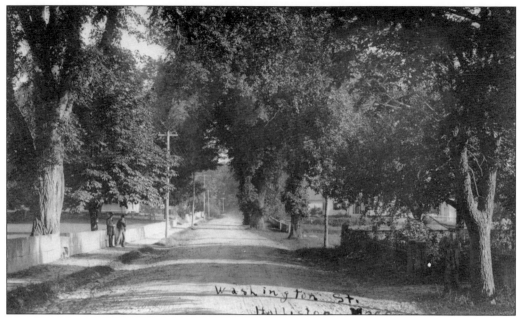

Washington Street was just a dusty, narrow road when traveling west toward Phipps Hill and beyond to Milford. The stone wall at the left still exists in front of the old William Batchelder home. The wall, built of granite slabs, was Batchelder's community work project during the Civil War to employ idle shoe shop workers. (DC.)

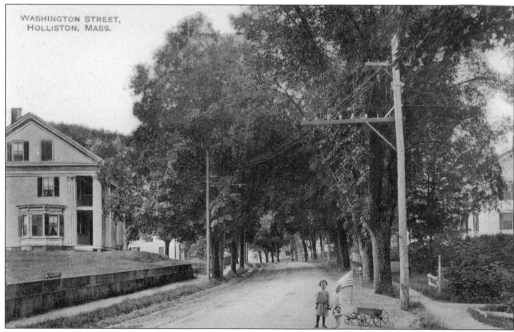

Two children pose for a picturesque view of Washington Street at the William Batchelder home. A grand home befitting one of Holliston's notable "moneyed men," he transformed the shoe industry to its highest level from 1820 to the Civil War era. The trolley tracks are at left, placing the photograph's date at sometime near 1900. (DC.)

44

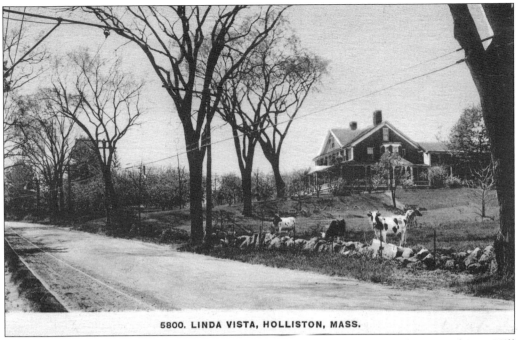

5800. LINDA VISTA, HOLLISTON, MASS.

For all those commuters who spend a portion of their travel slowly crawling up Phipps Hill during rush hour, hearken back to a time when the scene included cows, stone walls, a glimpse of the Linda Vista farm, and the trolley tracks on the route from Framingham to Milford; it was once a convenient and pleasant way to travel but is a now congested route. (DC.)

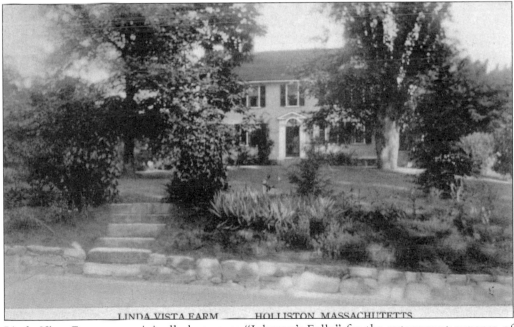

LINDA VISTA FARM HOLLISTON MASSACHUSETTS

Linda Vista Farm was originally known as "Johnson's Folly" for the extravagant expense of building a house meant to outdo his neighbors in 1810. The home remained in the Johnson family and was acquired by grandson Louis E.P. Smith, who operated it as a gentleman's farm well into the 20th century. (DC.)

45

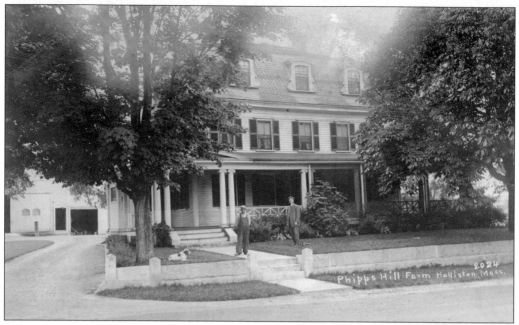

Phipps Hill Farm, located at Washington and Highland Streets, was the home of Andrew J. Cass (1828–1902), the man standing proudly on the lawn of his home. A lawyer by profession, he was a gentleman farmer and was famous for participating enthusiastically at town meetings, where he kept an ever-vigilant eye upon each and every line item in the town accounts, right down to the purchase of pencils by the school committee. Not a fan of the new trolley line that passed by his home in 1895, he was struck and killed by a trolley car in 1902 at the bottom of Phipps Hill. (DC.)

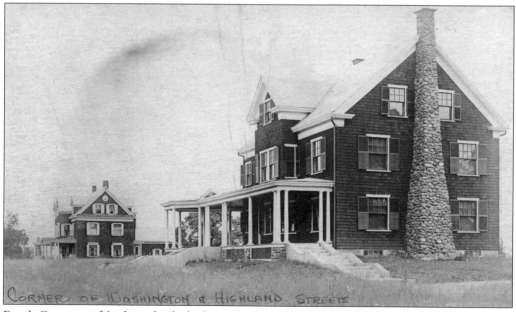

Frank Cass, son of Andrew, built the home in the background after his father died in 1902. The house in the foreground was the home of Ernest T. Manson, who was prominent in early golfing circles from 1900 to 1930 before golf became a professional sport. (PG.)

46

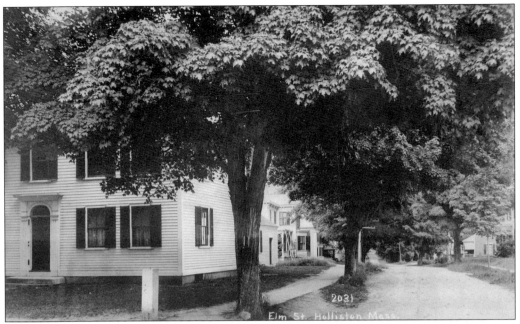

Although the shade trees have disappeared, the house once known as the Currier Mansion still remains at the corner of Washington and Elm Streets. (DC.)

The Town of Holliston officially designated the streets with names in 1856, and Elm Street, lined with rows of elm and maple trees, was aptly named. Deacon Timothy Daniels planted the first elm trees along the street when he built his home at the corner of present-day Elm and Grove Streets. The stately elms are gone, but Timothy's name lives on at his former home, now the Timothy Daniels House, a skilled nursing facility. (DC.)

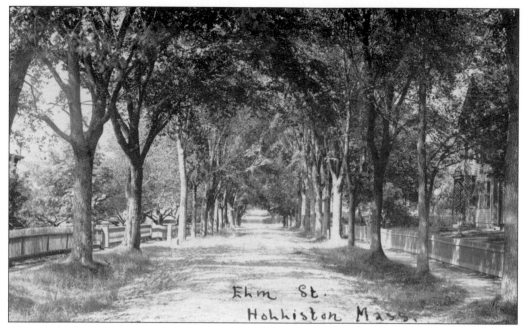

Along Elm Street were many homes as well as a straw hat factory, located at the brook. Shoe factories also were located there and were later converted into residences. Elm Street reflected the changes and transformation in Holliston from a bustling center of industry to a quiet, verdant street of residences, located just around the corner from Washington Street and the square. (PG.)

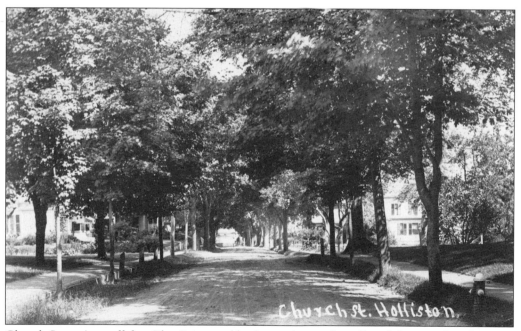

Church Street is parallel to Elm Street and leads travelers to the railroad depot and to the roads that continue to Millis and Medway. The photograph was taken in the early 20th century as the fire hydrant at the right reveals. Note that paving was still a future project, which began in earnest in the 1920s. (DC.)

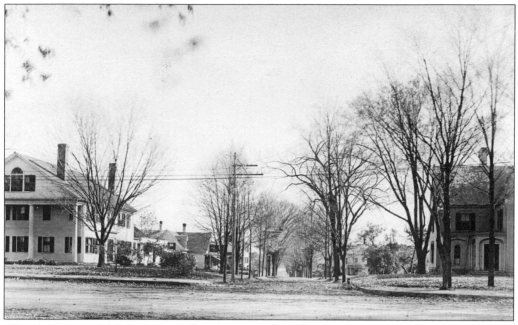

Church Street, which is situated directly across from the Congregational church, was not so named for its proximity to St. Mary's Church, as it had not yet been established when the street was named in 1856. The photograph also shows the elm trees that once graced its entire length. (PG.)

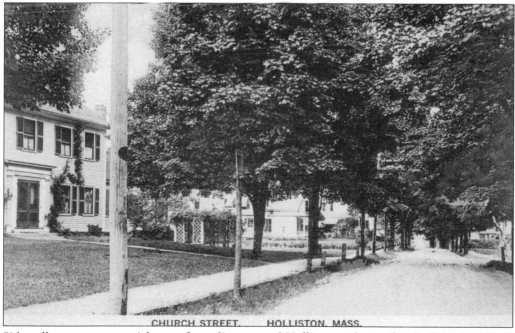

CHURCH STREET. HOLLISTON. MASS.

Sidewalks were an essential part of traveling around Holliston and were first built in the 1850s. Even before the streets were paved, sidewalks were given extra attention. (PG.)

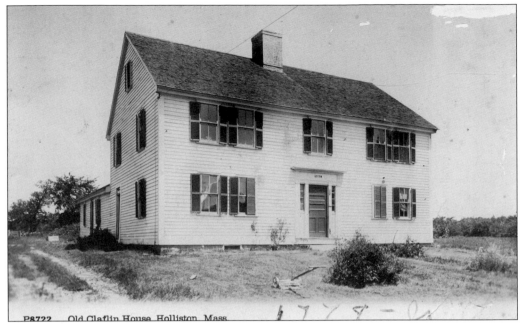

P8722 Old Claflin House, Holliston, Mass.

The Old Claflin House, located at 1797 Washington Street, was constructed in 1778 and was occupied by a descendant of the builder for 115 years. Although George Washington did not stop here during his 1789 journey through Holliston, a young Miss Claflin years later recalled watching him pass by just before George stopped next door at the Littlefield Tavern for rest and refreshments. In 1913, the family met there and celebrated their long history in the towns of Holliston, Hopkinton, and Milford. (PG.)

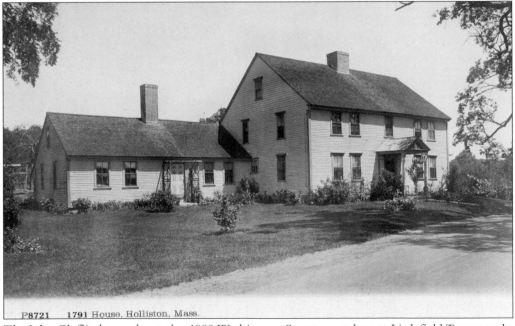

P8721 1791 House, Holliston, Mass.

The John Claflin house, located at 1989 Washington Street, next door to Littlefield Tavern and a half mile west of the Old Claflin House, was built in 1791. John Claflin was active in town affairs and was a prominent member of the Universalist churches in Holliston and in Milford. (PG.)

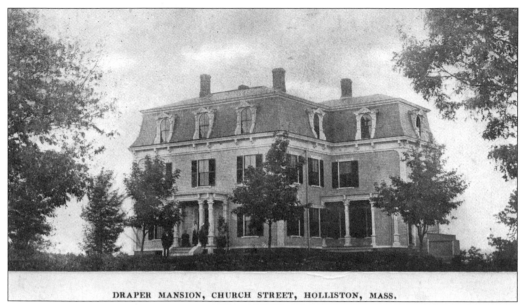

DRAPER MANSION, CHURCH STREET, HOLLISTON, MASS.

"Doesn't it look delightful?," writes a visitor to the Draper Mansion. Indeed, the house was a delightful and lovely example of the Second Empire style of architecture. The home stood on a hill north of Church Street and east of the railroad with a direct view of Elm Street to the west. (DC.)

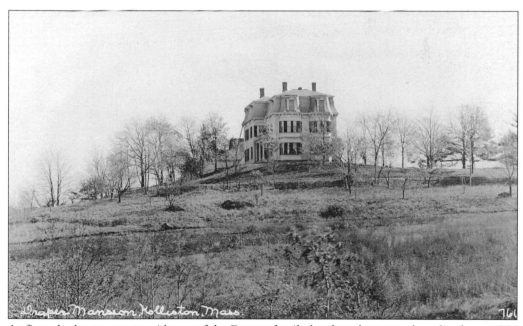

At first, the home was a residence of the Draper family but later became a boardinghouse. No longer considered valuable for its style and size, the home deteriorated and was torn down in the 1920s. (PG.)

51

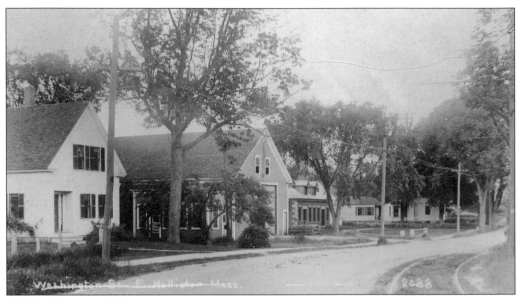

As travelers today round the curve and head east to East Holliston Corner, the view has changed. In decades past, the house at left was moved back from the street and is now the home of the Family Pharmacy. The old trolley carbarn has been cut in half and was known for many years as Gates Garage; Keystone Automotive now uses it. The old brick and stone building of the Holliston Water Company has been replaced by the Dunkin' Donuts. No longer does motor vehicle traffic have to share the street with the trolley cars. (PG.)

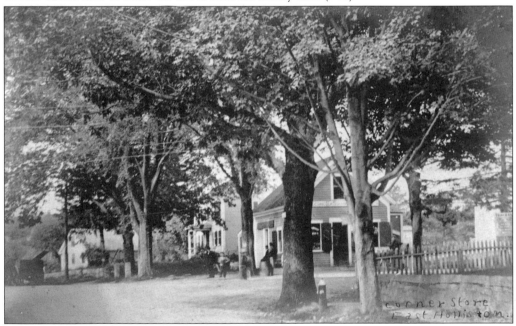

Proceeding farther on East Holliston Corner, now known also as Rossini Corner, the sharp turn onto Concord Street was a major stop for the trolley cars heading north to Framingham or south to the square and to Milford. Also located here was the Corner Store, a popular meeting place for residents in the area as they waited for a trolley to arrive. The photograph was taken in 1900; note that the fire hydrants have made their appearance here. (DC.)

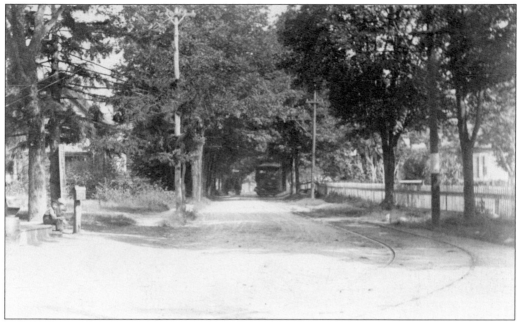

At East Holliston Corner, the trolleys could pass each other at points where the tracks allowed for one to stand by as the other passed. Rates also changed near East Holliston. If a rider from Framingham got off at Baker Street, the fare was 5¢, but if the rider went to the corner at Washington Street, the fare increased to 10¢. For most, it was worth the short walk. (PG.)

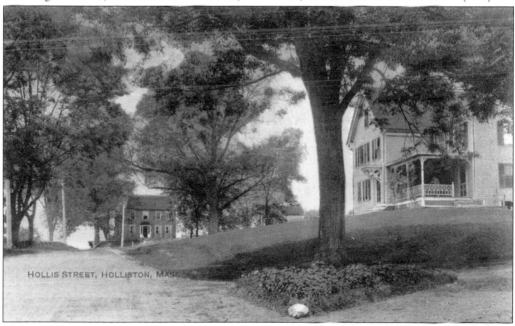

HOLLIS STREET, HOLLISTON, MASS.

Hollis Street at the corner of Highland Street appears familiar in this photograph taken after 1900. At the right is the house of the Finn family farm. The original house burned in 1899, and Mary Finn, along with her children, rebuilt the home seen today and turned the farm into a successful operation. A farm owned and operated by a woman was a unique situation in 1900. The farm is still owned and operated by the Finn family. (DC.)

Mary E. Cutler was a "successful farmer." Mary inherited the 68-acre farm on Highland Street from her father, and she was determined to carry on the farm against the advice of friends, who thought it impossible for a woman to make agriculture a business success. (PG.)

Proceeding carefully, Mary's farm increased under her direction. She chiefly concentrated on raising fruits and vegetables, which she sold directly to the consumer, with the surplus going to canneries. She maintained 1,400 peach trees and did not suffer a crop failure for more than seven years. In 1897, Mary Cutler spoke before the Worcester Horticultural Society about "Gardening for Women" and was featured in a *Boston Post* article in 1904 titled "Odd Occupations of American Women." (DC.)

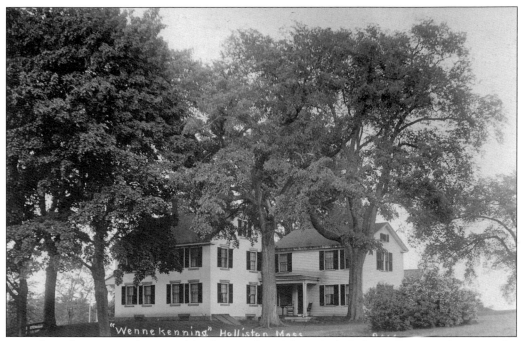

"Wennekenning" Holliston Mass.

Just a short distance south on Highland Street from Mary Cutler's farm was Wennakeening, the home of several generations of the Cutler family. The home was built on one of the original homesteads in Holliston that dated back to the 17th century and was located near Pout Lane, the ancient Native American pathway that wended its way west from South Natick to Mendon. The path had also carried the first settlers to the region eventually to be known as Holliston. (PG.)

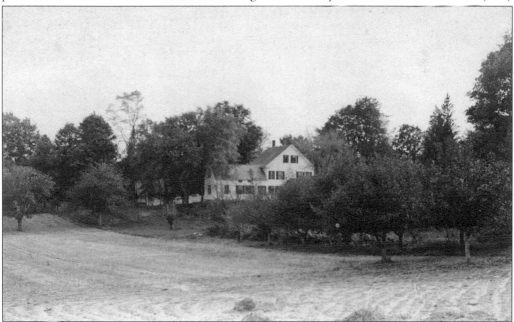

The fields of Wennakeening, located between the house and Lake Winthrop, were farmed from the 1600s to the early 20th century. Also located on the farm in later years was the fondly remembered Girl Scout's Camp Featherfin, located on the shore of the lake. (DC.)

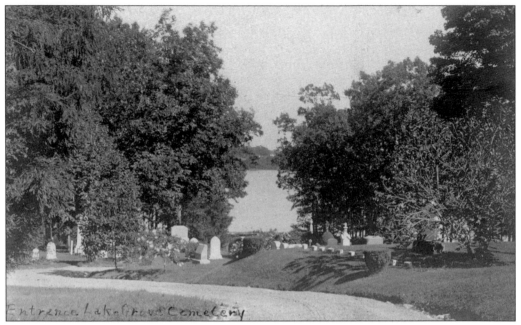

Entrance Lake-Grove Cemetery

Lake Grove Cemetery was founded in 1860, inspired by the idyllic, garden-like Mount Auburn Cemetery in Cambridge. With the pleasant waters of Lake Winthrop providing a peaceful place for reflection and calm, Lake Grove, a nonsectarian cemetery, is the resting place of many notable Holliston residents. (DC.)

This postcard was sent on August 30, 1909, and reads as follows: "Dear Laura, Don't you think this looks like a delightful resting place? Just to look at it makes you want to lie down and die. I send you this, for you write as if you were tired. May." (DC.)

Four

ON THE ROAD AND RAIL

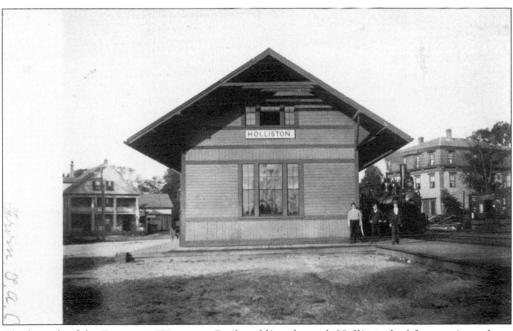

The branch of the Boston & Worcester Railroad line through Holliston had four stations along the route, and the main depot located on Railroad Street was the center of transportation and commerce in Holliston. The line was completed as far as the depot in 1847. (PG.)

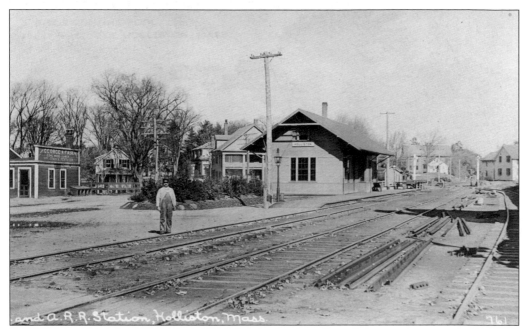

Although the trains have ceased passing through and stopping at the station, the tracks have been pulled up, and the bike trail is in process of completion, the old depot building still exists as Casey's Crossing, a different sort of meeting place today. Instead of a ticket out of town, Casey's now offers draft beer and legendary ribs, pizza, and hamburgers. (DC.)

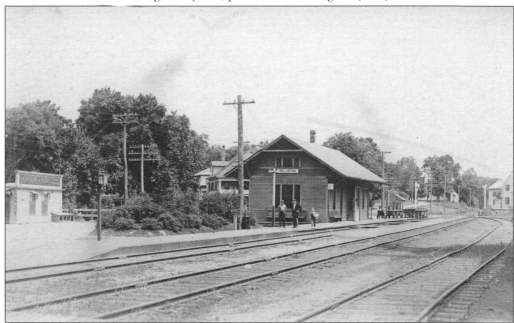

During its heyday, the depot served the travelling public as well as all the industry in Holliston. All the shoes, boots, straw hats, and even the granite quarried in Holliston and Milford passed by the depot as the local products were distributed throughout the United States. At the depot, three tracks bear witness to the activity there, as the yard served to allow trains to pass at this halfway point between Framingham and Milford. (PG.)

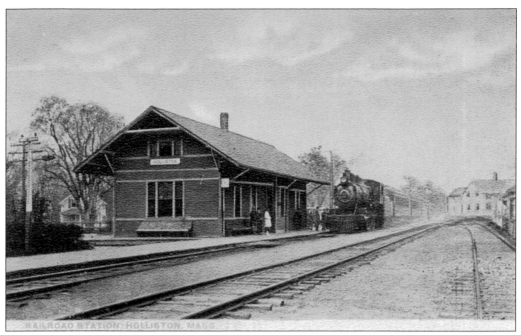

Passengers await the arrival of the train from Framingham on its way to Milford. At either destination, travelers could transfer to other lines that branched out all across the United States. Travel from Holliston was easy when the train came to town, and residents could reach Boston in about one hour, a significant improvement over the daylong trip that it once took. (PG.)

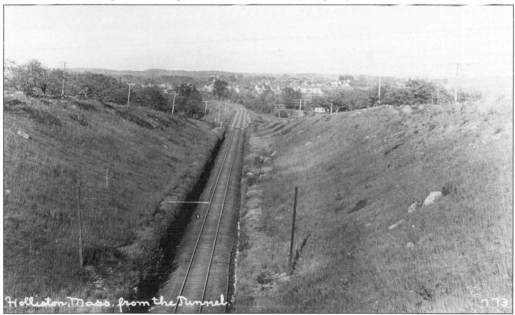

While the railroad had been constructed as far as the depot, the difficult work of leveling the grade and cutting though the ledge at Highland Street continued as the workers forged on toward Milford during 1848. All the work was done by pick and shovel; the hard labor was done by mostly immigrant Irish labor. Many of the workers settled in Holliston and lived in the neighborhood that grew up along the tracks and was known as Mudville. (PG.)

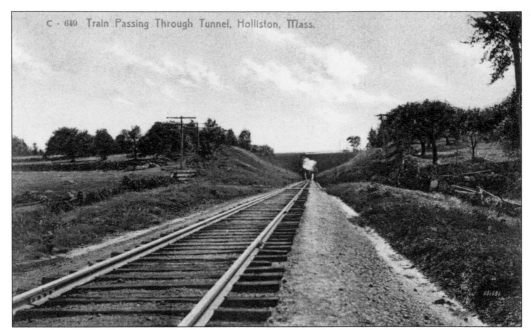

A steam engine appears from the tunnel on its way to Milford. Once the ledge and grade at Highland Street were conquered, it was relatively smooth work from here to Milford. The completed railroad was opened to the public on Saturday, July 1, 1848. (PG.)

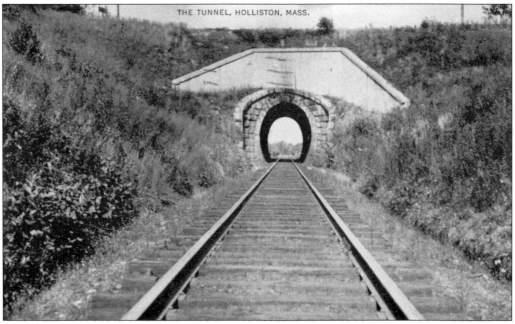

THE TUNNEL, HOLLISTON, MASS.

Under Highland Street, at the most difficult part of the railway project, was located the tunnel. About 30 feet in length, an elliptical passageway lined in brick, the tunnel exists still today and is an engineering curiosity that is now part of the Holliston Upper Charles Trail. (PG.)

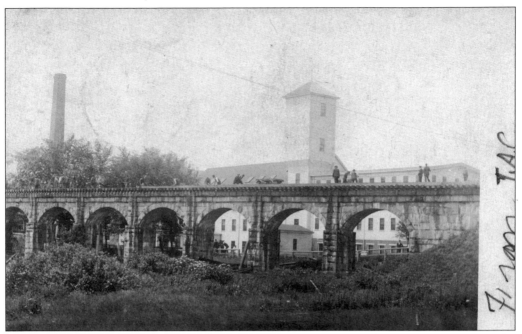

The eight-arch railroad bridge spanned Boggastow Brook, a supplier of waterpower to the factory at Mill Pond. Rather than filling in the grade, Holliston was rewarded with one of its iconic landmarks, a reminder of past railway and industrial glory. (PG.)

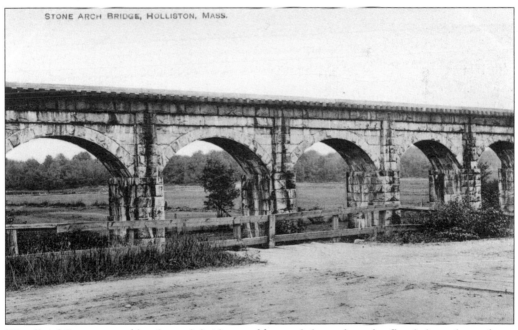

Woodland Street passed by the arch bridge, and beyond the arches, the flooded cranberry bogs of George Batchelder can be seen in the distance. The cranberry bogs contained several varieties unique to Holliston, and Batchelder cultivated the vines at the same time as the railway was being constructed. The arch remains, but the bogs are now dormant. (DC.)

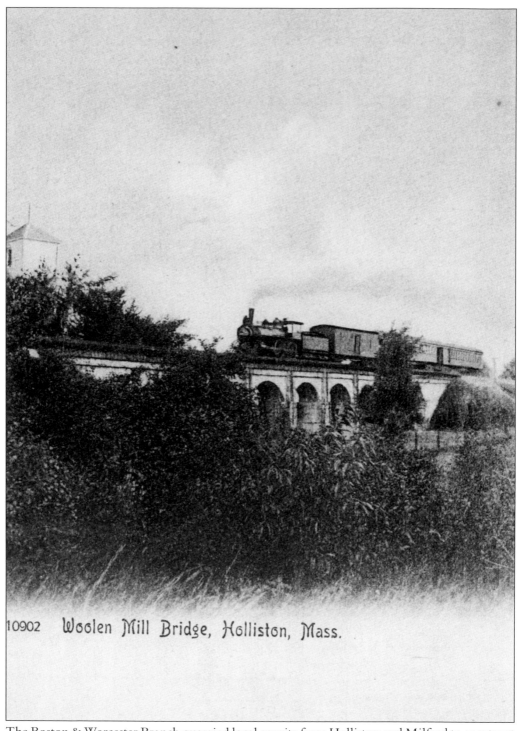

10902 Woolen Mill Bridge, Holliston, Mass.

The Boston & Worcester Branch quarried local granite from Holliston and Milford to construct the arch bridge and all the other stone structures along the route. Today, they call to mind the golden age of railroads that helped many small towns in America grow and prosper to a greater extent than ever before. (DC.)

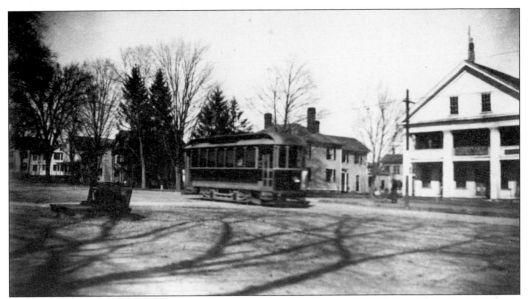

Although Holliston had a railway that would transport passengers to Framingham and Milford, many thought a trolley line would improve travel even further. Work began in 1895 along Concord and Washington Streets, and the first car to make the trip through Holliston from Framingham to Milford was met with great fanfare on May 14, 1896. (PG.)

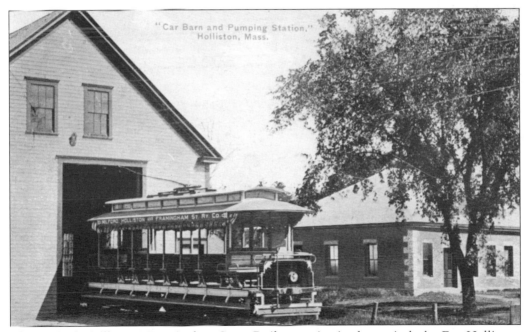

The Milford, Holliston & Framingham Street Railway maintained a repair shed at East Holliston. Part of the barn still exists as Keystone Automotive. An explosion on January 2, 1938, damaged the brick and stone pumping station of the Holliston Water Company. The Dunkin' Donuts building now occupies the location. (DC.)

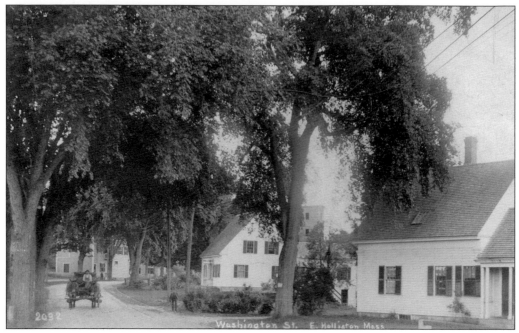

The approach to the East Holliston Corner has changed as trees have been removed and the street widened to accommodate vehicles larger than the wagon making its way toward the square. Only the house on the right still exists today. (DC.)

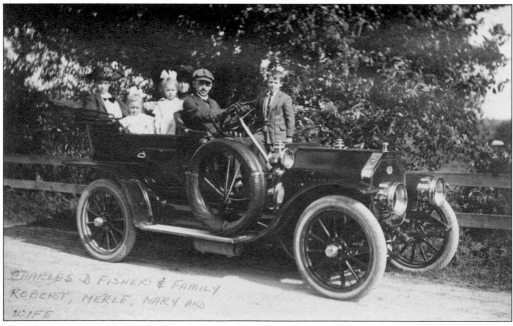

Greetings from on the road! Charles D. Fisher, proud owner of a touring automobile in 1912, and soon to become the president of the Holliston Savings Bank, produced his own postcard to celebrate the Fisher family's excursions. (PG.)

Five

Houses of Worship

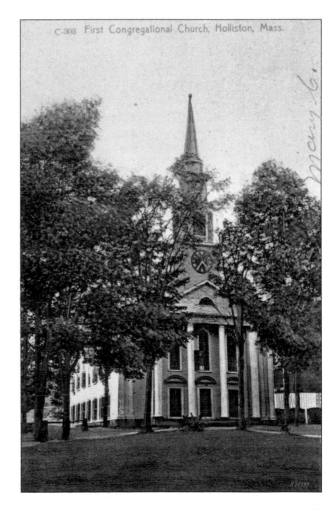

The Congregational Church of Holliston was the first church founded in Holliston and graces a scene that supports Holliston's character as a quintessential New England town. (DC.)

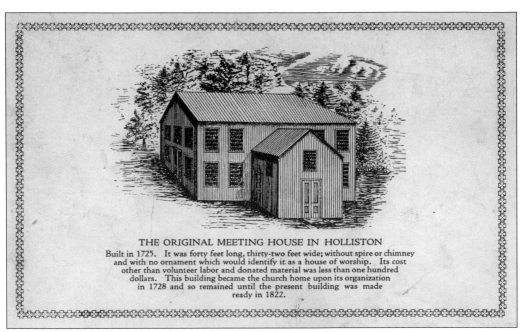

THE ORIGINAL MEETING HOUSE IN HOLLISTON

Built in 1725. It was forty feet long, thirty-two feet wide; without spire or chimney and with no ornament which would identify it as a house of worship. Its cost other than volunteer labor and donated material was less than one hundred dollars. This building became the church home upon its organization in 1728 and so remained until the present building was made ready in 1822.

The original meetinghouse was located near the present church and was said to be painted a reddish-orange color. White paint would need to wait two centuries before it was economical. Since a meetinghouse was of the utmost importance to a town, it was the first public building erected in Holliston. (DC.)

Here, the sweeping expanse of green lawn and the towering maple trees are paired with Congregational Church of Holliston. (DC.)

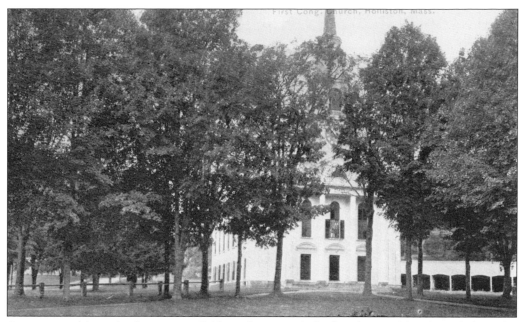

As soon as white paint became available and economical, churches readily adopted the color scheme. In this photograph, taken in the early 20th century, the horse barns are still evident, revealing that horse-drawn conveyances were still an essential mode of transportation. (DC.)

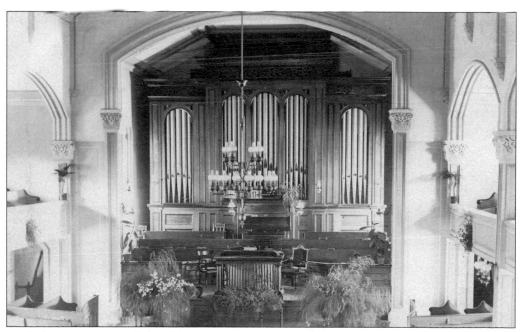

Inside the Congregational church's sanctuary is a peaceful setting. The traditional character has been maintained throughout, and the organ still occupies a prominent place behind the altar. (DC.)

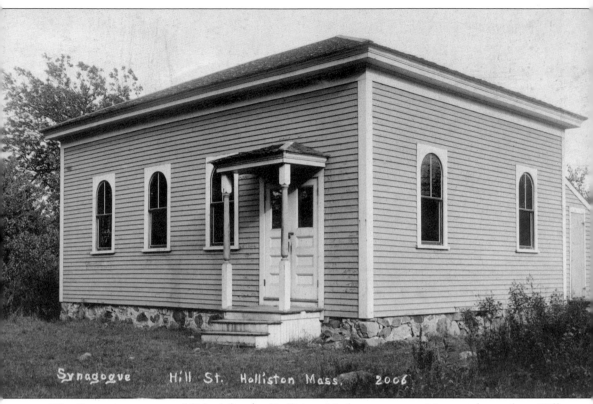

Synagogue Hill St. Holliston Mass. 2006

The first synagogue established for the Holliston–Medway communities was located on Hill Street in Holliston. A dedication celebration was held on August 28, 1899, and was attended by a large group of Jewish residents and Gentile neighbors. Several farms owned by Russian and Polish immigrants had been established in the area, and the center of the community was brought together by the building, a 26-by-36-foot structure with a roof of the Foursquare type. At the time of the dedication, seats were still to be added, and a jubilant crowd and a small band of musicians carried the Torah, which had been kept at the home of Makin Glatky, ceremoniously in a horse and carriage to the synagogue. Rabbi Shoher of Boston delivered the welcoming address, which began with a prayer for their newly adopted country. He spoke in English first and again in what a local reporter guessed was German for those who could not understand English. (DC.)

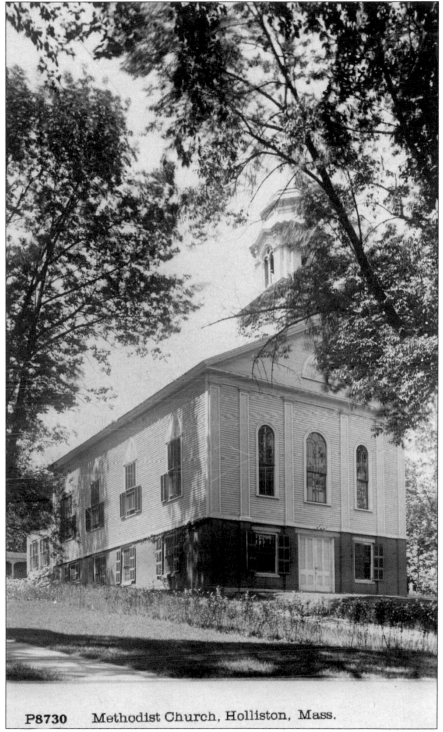

P8730 Methodist Church, Holliston, Mass.

Rev. George Pickering formally organized the Methodist church in Holliston in 1831. Before there was a fire alarm whistle, the Methodist church bell warned townspeople of building fires, while the Congregational church summoned fire volunteers for outside fires. (DC.)

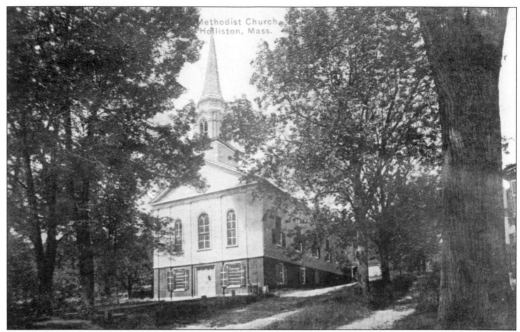

Establishing the Methodist church in Holliston did not go smoothly in the beginning, for their society was only the second denomination established here. Finding a building lot was a challenge until Elizabeth Prentiss, the daughter of Holliston's second Congregational minister, in an ecumenical gesture, stepped forward and offered the lot next to her home for the new church. (PG.)

Methodist Hill, the low rise of a hill that travelers encounter on Washington Street as they approach the square, was so named for its proximity to the Methodist church. The old church is now the Masonic hall. (PG.)

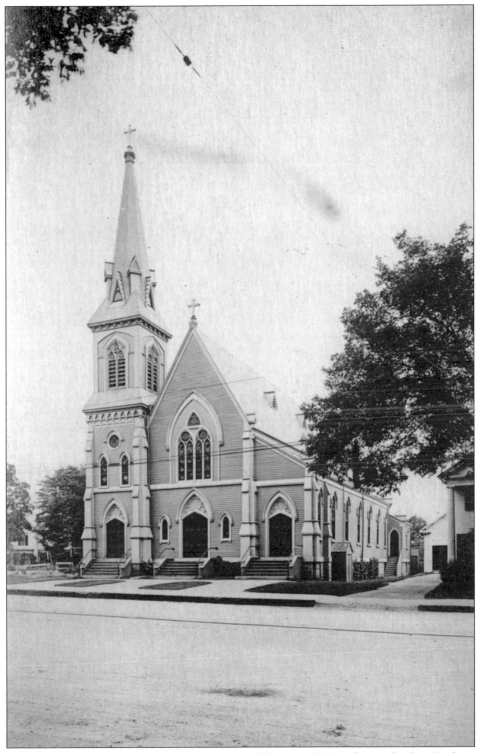

Fr. Patrick Cuddihy celebrated the first Mass in Holliston in 1867 and is credited with choosing the location for St. Mary's Church. (PG.)

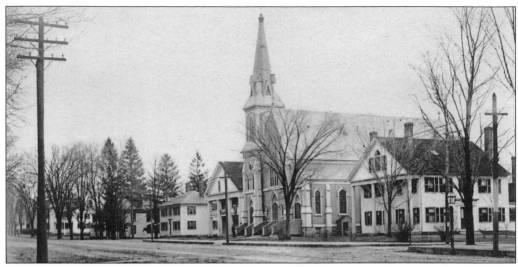

An early photograph of St. Mary's Church reveals the parish house, church, and the old commercial block nestled between the church and Currier Mansion on the corner of Elm Street. Fr. Robert J. Quinlan was the first priest to settle in Holliston in 1874; he watched over a growing community that quickly became involved in civic affairs. Father Quinlan also became involved when he was elected to the school committee in 1874. (PG.)

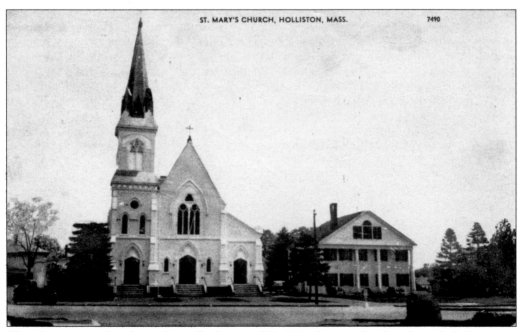

ST. MARY'S CHURCH, HOLLISTON, MASS. 7490

Churches were painted a variety of colors, and St. Mary's sported colors from dark brown to tan and gray. White paint became affordable in large quantities in the early 20th century, and St. Mary's was quick to adopt the hue in place of darker colors. (DC.)

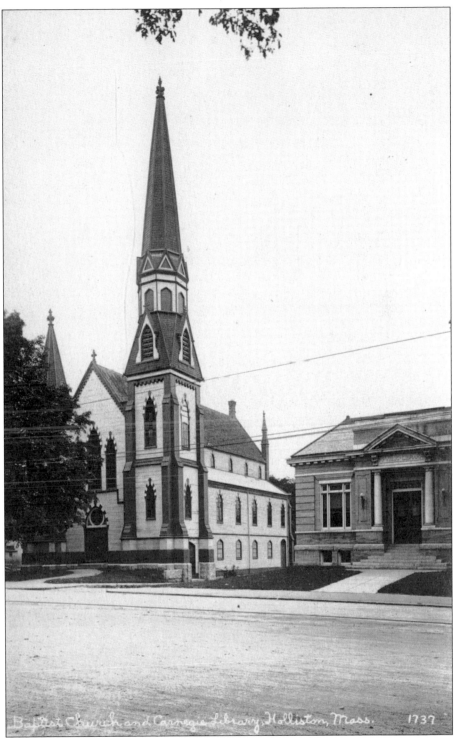

Baptist Church and Carnegie Library, Holliston, Mass. 1737

The Baptist Society in Holliston at first conducted services in private homes until the membership became too large. The society dedicated their church building at the corner of Washington and Charles Streets on January 26, 1870. (PG.)

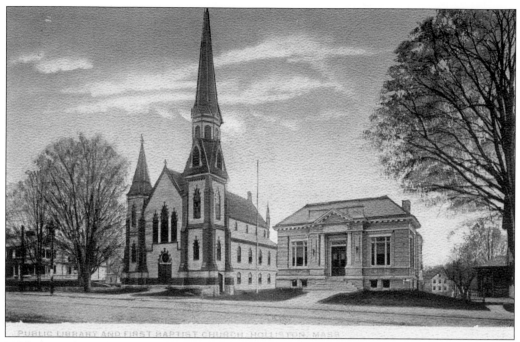

With the traditional colors of tan and brown, the Baptist church existed long before the Holliston Public Library arrived next door. The Baptists started building their church in 1866, and work continued on the structure as services were held amidst the construction. The public library welcomed the first book borrower on July 5, 1904. (PG.)

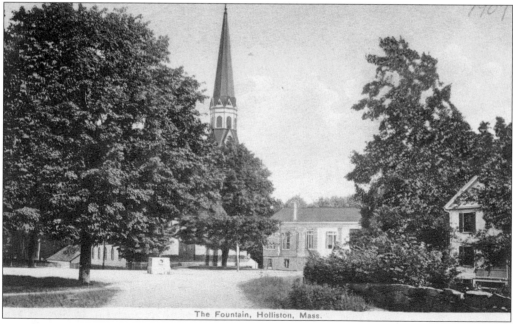

The Fountain, Holliston, Mass.

Travelers down Hollis Street were met by the steeple of the Baptist church, the public library, and the old fountain located in the middle of the street. With all that is visible, the scene best describes Holliston near the square after 1905. (DC.)

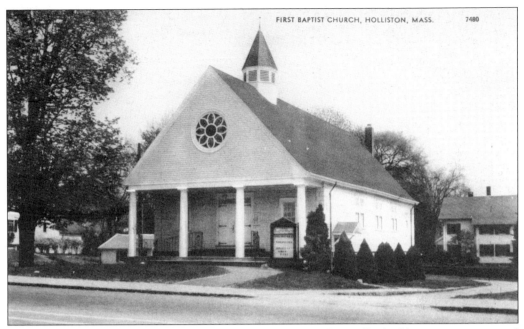

The Hurricane of 1938 destroyed the old Baptist church, and a smaller building was constructed in its place. The year 1938 reflected difficult economic times, and so the majestic Gothic style of church buildings was harder to fund. Although a smaller sanctuary, the building accommodated the society until the 1960s. (DC.)

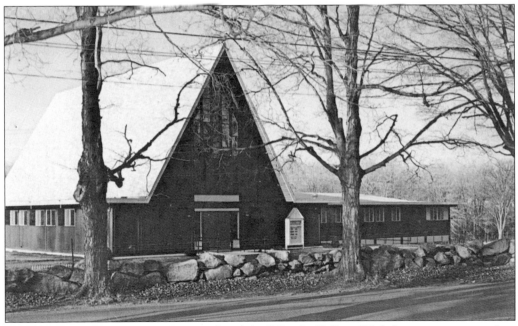

The Baptist church constructed a new church building in 1962 on High Street to accommodate a growing membership and expanding activities. The church reflects the popular A-frame style of religious architecture so popular in the mid-20th century. (DC.)

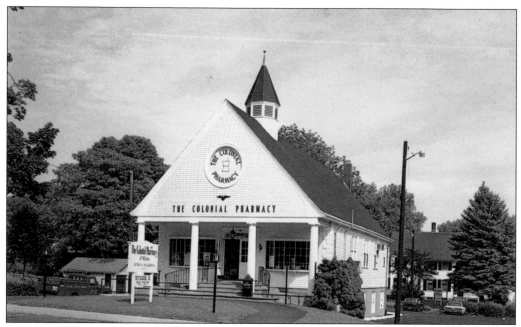

The old Baptist church did not disappear. The building was converted into commercial space; its location in the square is a valuable asset for any business. A pharmacy was the first new use of the building, and today, a bank now occupies what started out as a house of worship. (DC.)

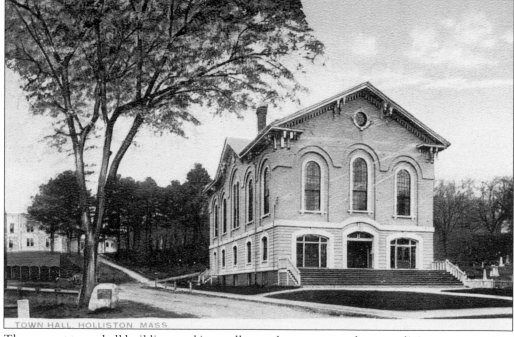

The present town hall building, and its smaller predecessor, served many religious communities that had not yet established their own structures in Holliston. At one time or another, Baptists, Universalists, Roman Catholics, Episcopalians, Mormons, and Millerites were all welcome at the town hall to hold their religious services. (DC.)

Six

PARKS AND RECREATION

Houghton's Pond, East Holliston, Mass. 751

"Happy the man whose recollection fond / Pictures a boyhood passed beside a pond," wrote William Addison Houghton. He remembered the body of water behind his home in East Holliston in his 1911 poem "The Pond"; it was about a childhood happily influenced by the body of water at his back door, which still bears the name of his family, who, at one time, controlled the water rights that powered their factory. (DC.)

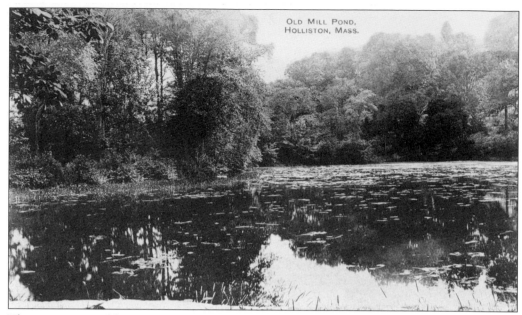

There were several locations in Holliston where dams were built to control the flow of brooks for use as waterpower for factories. Such was the case at Linden Street, where the waterpower was gleaned from an innocuous stream that provided power for a factory. Evidence of the old Payson and Cutler factory, which burned in 1882, and dam are still evident today. (DC.)

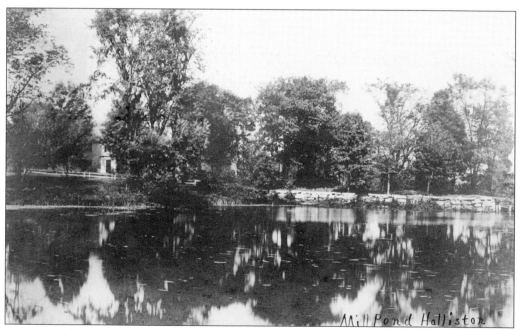

A view looking north shows the remains of the foundation and dam of the carpentry and box factory that burned in 1882. Slowly over time, the old millpond and the brook are being reclaimed by nature and are gradually filling in with mud and vegetation on the way back to their former courses. (PG.)

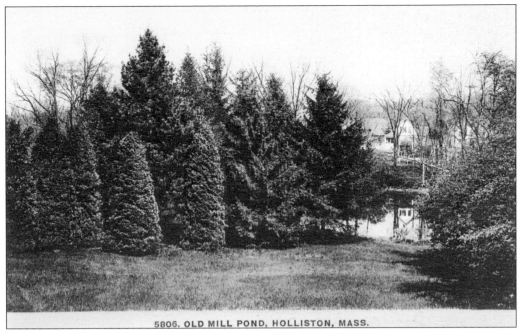

5806. OLD MILL POND, HOLLISTON, MASS.

Looking east toward Avon Street, the old millpond flowed along a languid course, sending the water toward a confluence with Jar Brook and on to Mill Pond on Woodland Street, where the beginning of Boggastow Brook carried the water farther on, eventually joining the Charles River. (PG.)

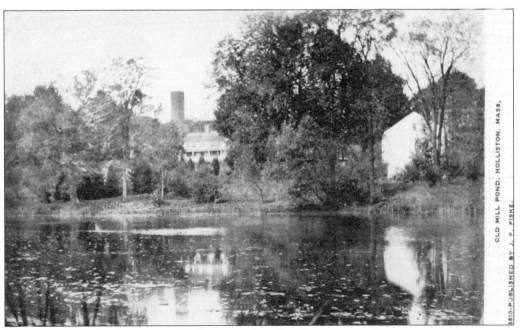

OLD MILL POND, HOLLISTON, MASS.

3810-PUBLISHED BY J. F. FISKE.

The old millpond no longer provided waterpower after the disastrous fire of 1882. This postcard, published by James F. Fiske and sold at his store in the Andrews Block in the first decade of the 20th century, catches a glimpse of the Holliston Water Company's standpipe on Jasper Hill. (PG.)

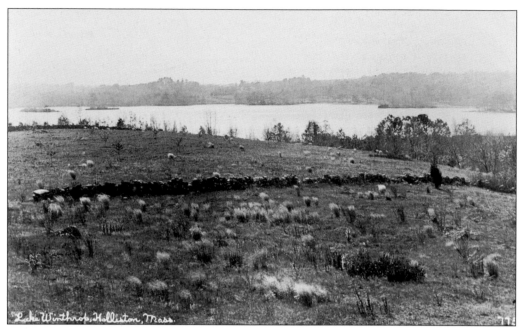

A rare, unique view of Lake Winthrop from Norfolk Street was captured on this postcard from the 1890s. The three islands, known by various names such as Uncle Tom, Saco, Blueberry, and Grape Island, located near Pleasure Point, appear low and treeless. Finding a clearer view of the lake as this is a challenge today. (DC.)

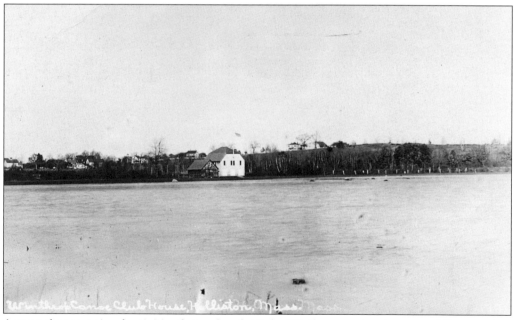

Among the recreational activities that endured at Lake Winthrop was boating, especially canoeing. The Winthrop Canoe Club even maintained a clubhouse and grounds at the north side of the lake. The heyday of the club, from 1890 to 1910, provided the town with activities on shore, with baseball games and lawn parties in summer and ice fishing and skating in wintertime. (DC.)

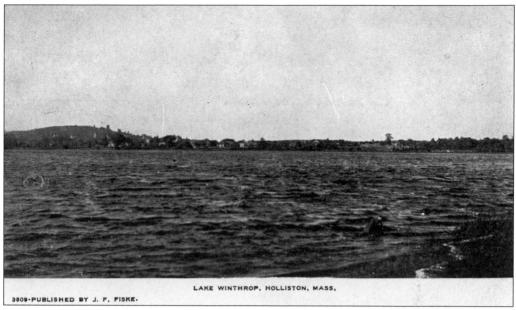

LAKE WINTHROP, HOLLISTON, MASS.

3809-PUBLISHED BY J. F. FISKE.

Lake Winthrop, known as Wennakeening by the Native Americans who enjoyed the location long before the arrival of European settlers in the 17th century, was later called "Dean Winthrop's Pond," marking the westernmost reach of his land grant. Wennakeening, loosely translated as "pleasant waters," is perhaps a more enduring name for this great pond than one that bears the name of a man who most likely never set his eyes upon it. (DC.)

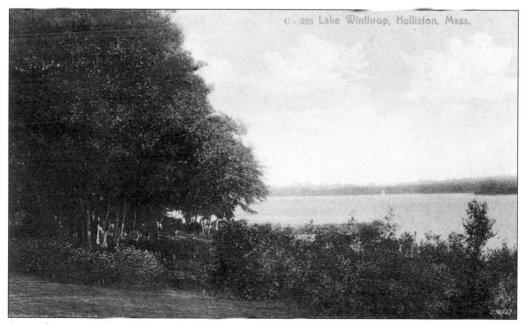

C - 320 Lake Winthrop, Holliston, Mass.

As outdoor activities and recreation became popular during the last decades of the 19th century, Lake Winthrop became a focal point in Holliston for everything, from swimming, skating, boating, and fishing to all social gatherings. Lake Winthrop was Holliston's first area set aside for a park and exclusively for recreation as early as the 1850s. (PG.)

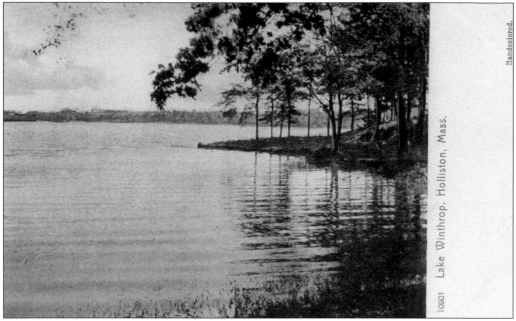

The first area on Lake Winthrop set aside for recreation was at Pleasure Point on the north side. It was accessible by a road off Arch Street. The Fair brothers cleared an area near the shore, constructed a bandstand, and laid out a baseball field. (PG.)

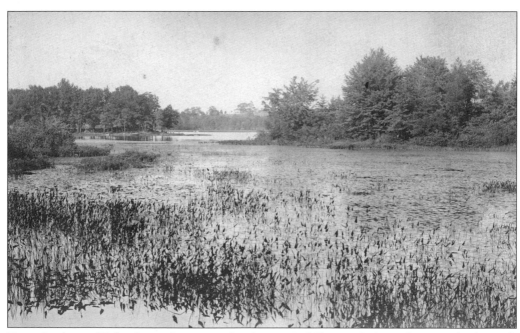

From the shore of Lake Grove Cemetery, the view toward Pleasure Point and Grape Island reveals a sea of cattails and pond lilies. Grape Island was a favorite spot of campers seeking a relatively remote location from the mainland and yet still close to town. (PG.)

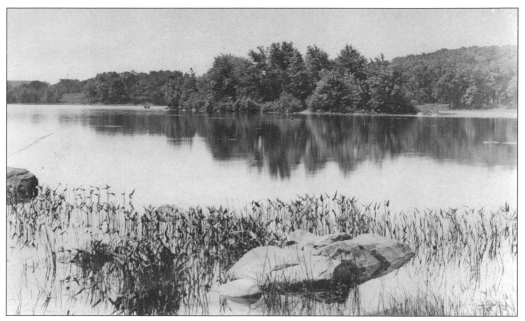

Grape Island can be seen from Pleasure Point. Easily reached by boat or swimming, it was a popular camping spot. During the winter, an easy walk from the point made for a good camp for ice fishermen. Once upon a time, grapes were on the island. (PG.)

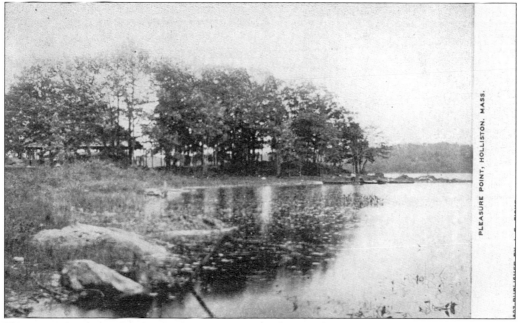

Pleasure Point, located at the northwest corner of Lake Winthrop, was a lively recreational center, established in 1880. It was Holliston's first organized recreational area. The old bandstand can be seen through the trees on the shore. Concerts, baseball games, and picnics were often held here. (DC.)

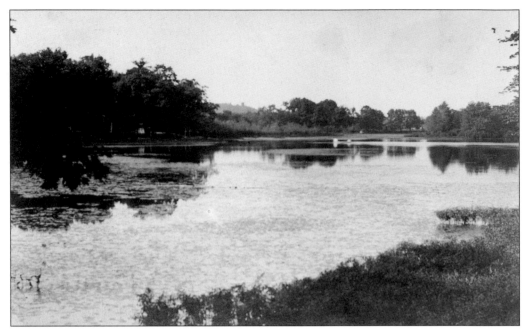

Looking north across Lake Winthrop toward the shore at the foot of Winthrop Street, the Winthrop Canoe Club maintained a boathouse and park area. Many summer days found the lake filled with canoes and rowboats, with many challenges to race around the islands and stops at Valentine's Rock located just off the northern shore. (DC.)

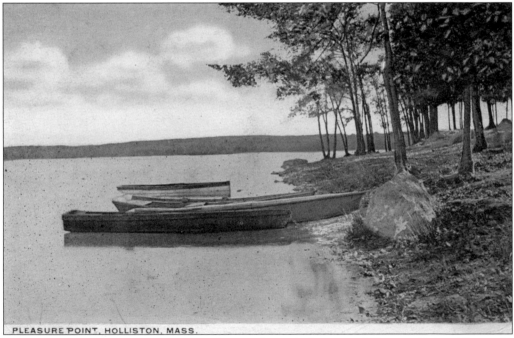

PLEASURE POINT, HOLLISTON, MASS.

Beach sand was not always in vogue during the early history of Pleasure Point. The main activity here was boating. Occasionally, there would be complaints from visitors about the rowdy behavior of some young male swimmers who eschewed swimming attire and taunted the horrified canoeists as they passed by. (PG.)

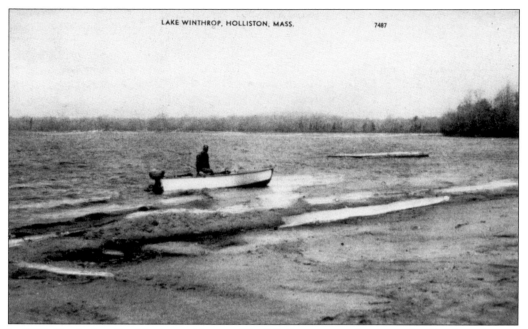

LAKE WINTHROP, HOLLISTON, MASS. 7487

In 1937, Dr. Arthur Stoddard, a resident on Norfolk Street, gave three parcels of land on the east shore of Lake Winthrop for use as a park. The Town of Holliston agreed to keep the beach clear of weeds, remove undergrowth in the woods, and maintain it as a beauty spot for the benefit of residents and guests. And so, they have to this day. (DC.)

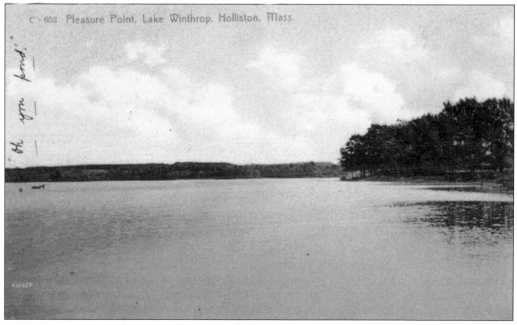

C-652 Pleasure Point, Lake Winthrop, Holliston, Mass.

Sent on April 1, 1911, this postcard states the following: "Oh you pond! To Miss Grace, Am having a dandy time. The thought of going to school next week, though, is discouraging." (PG.)

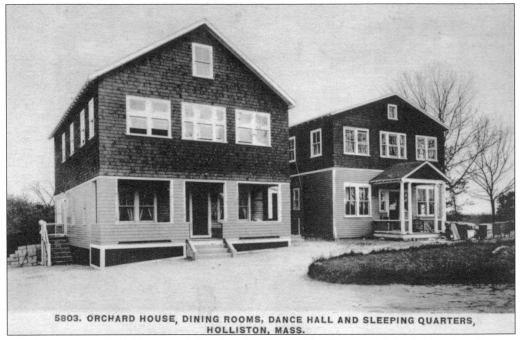

5803. ORCHARD HOUSE, DINING ROOMS, DANCE HALL AND SLEEPING QUARTERS, HOLLISTON, MASS.

Between 1900 and 1920, several Russian immigrant families established farms in the area near the Holliston-Medway town line. One man, Myer Gotz, owner of Soapstone Farm, was receiving so many friends and visitors to his farm that he had a better idea than cooping up his chickens. (PG.)

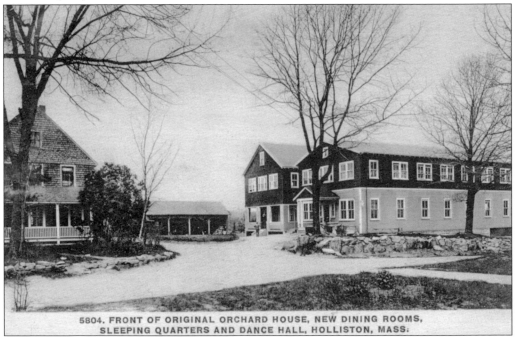

5804. FRONT OF ORIGINAL ORCHARD HOUSE, NEW DINING ROOMS, SLEEPING QUARTERS AND DANCE HALL, HOLLISTON, MASS.

Myer Gotz and his wife decided to transform his farm into a vacation resort. His new venture was a short walk to Lake Winthrop and offered lots of great food, thanks to Esther's culinary talents. (DC.)

86

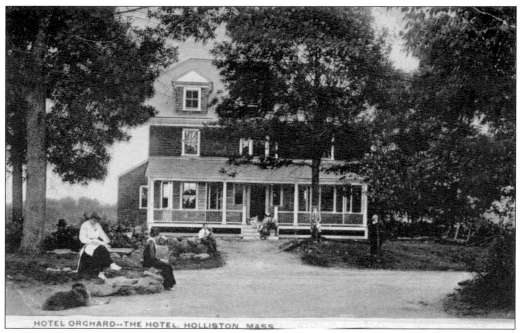

Myer Gotz opened Orchard House and soon packed his hotel, dormitories, dining rooms, and dance hall with crowds of happy vacationers who often walked the two miles from the train station, all the way up Norfolk Street, to his resort on Goulding Street. (DC.)

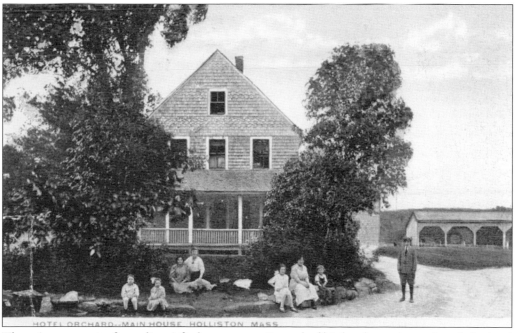

There is no report of any dissatisfied customers. Several of his loyal vacationers loved the land so much that a few of them stayed and established farms and homes nearby on Norfolk and Hill Streets. (DC.)

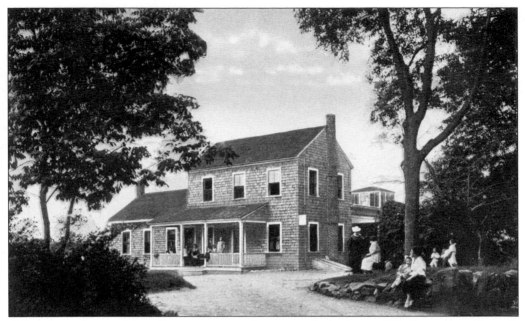

A popular raconteur, Myer Gotz was a gregarious man who had turned his best personality trait into financial reward. But attitudes about recreation and where to spend a vacation began to change in the 1920s as automobiles allowed for a wider choice of places to go and things to see. Orchard House thrived until 1929, when a devastating fire destroyed the buildings. Holliston would never see another resort like Orchard House again. (DC.)

HOTEL ORCHARD--RECREATION GROUNDS, HOLLISTON, MASS.

Today, the land that was once the Gotz farm, and later Orchard House, was located on Goulding Street, near present-day Dudley Road and Alden Street. The close proximity to Lake Winthrop was a strong incentive for the largely city-dwelling patrons to make the trip out to Holliston for rest, recreation, and for the legendary hospitality of the Gotz family. (DC.)

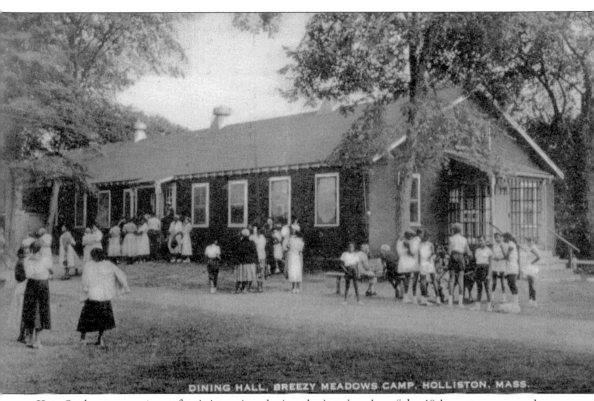

DINING HALL, BREEZY MEADOWS CAMP, HOLLISTON, MASS.

Kate Sanborn, prominent feminist writer during the last decades of the 19th century, owned a farm on Summer Street that straddled the Holliston–Medway town line. She named her estate Breezy Meadows. After her death in 1917, the property was later purchased by the Robert Gould Shaw House in Roxbury and was a popular summer camp for inner-city children. (DC.)

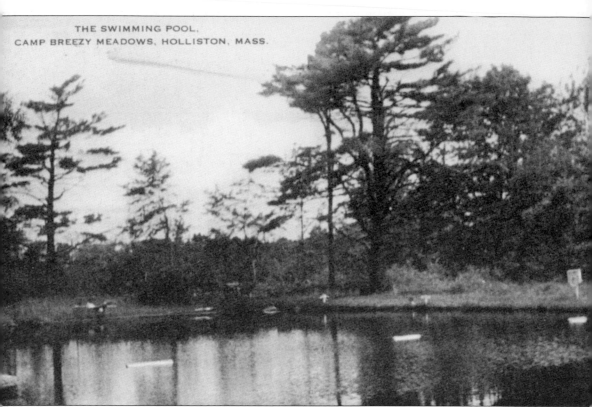

THE SWIMMING POOL,
CAMP BREEZY MEADOWS, HOLLISTON, MASS.

Breezy Meadows Camp provided recreation for a large number of children and young adults from the 1930s until the 1960s. The camp was not always isolated from activities around Holliston. In 1937, the Breezy Meadows Camp softball team challenged Holliston's league with a lineup comprised of an impressive list of athletes from Boston schools. (DC.)

DIVING — BREEZY MEADOWS CAMP, HOLLISTON, MASS.

Several of Kate Sanborn's old farm buildings were converted to dormitories and dining halls, and the grounds offered a pond for swimming and hiking trails. Today, reminders of the old camp can still be found in the land where the brooks, trees, trails, and pond still put forth hints of the very welcome refuge for many Boston children. (DC.)

FLAG RAISING, BREEZY MEADOWS CAMP, HOLLISTON, MASS.

Times had changed by the 1960s when the Robert Gould Shaw House of Roxbury provided other recreational opportunities to the community. The campgrounds fell into disrepair, and Kate Sanborn's house was torn down. Today, the W.A. Wilde Company now occupies part of the land that once was the vibrant center of activity for thousands of young Boston residents. (DC.)

Seven

HOLLISTON CELEBRATES

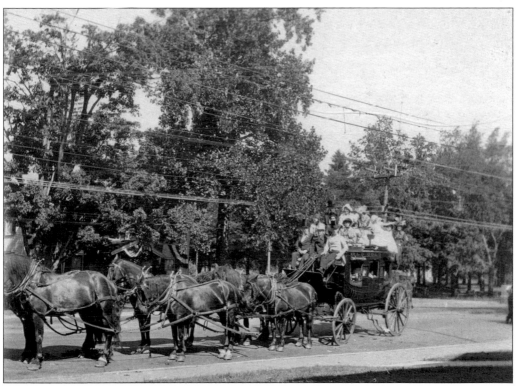

The Holliston bicentennial celebration of 1924 celebrated 200 years of town history. On September 1, episode No. 3 of the pageant featured the stagecoach, with driver Arthur Gooch holding the reins, and a cluster of finely costumed townsfolk hanging on for dear life. (PG.)

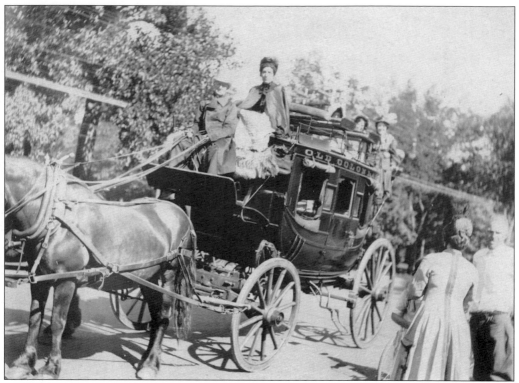

The 1924 bicentennial celebration pageant included nine episodes performed as vignettes along Washington Street and at a field off Highland Street. In episode No. 3, enthusiastic Hollistonians, attired in their best colonial "going-to-meeting" clothes, welcomed the arrival of the stagecoach at a tavern scene and put a miscreant in the stocks because "ye sinner fished on Sabbath." (PG.)

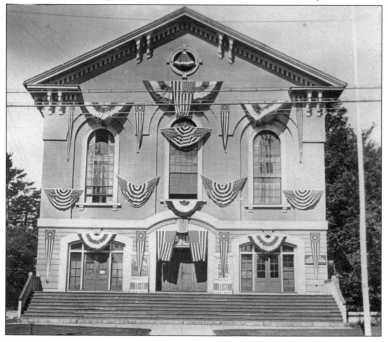

Town hall was always decked out with flags and decorations for civic events. An evening of the obligatory long speeches celebrating 200 years of Holliston history opened the event at town hall on Sunday, August 31. On September 1, 1924, rain threatened to postpone the celebration, but the skies cleared just in time to allow for the parade and outdoor pageant to proceed. (PG.)

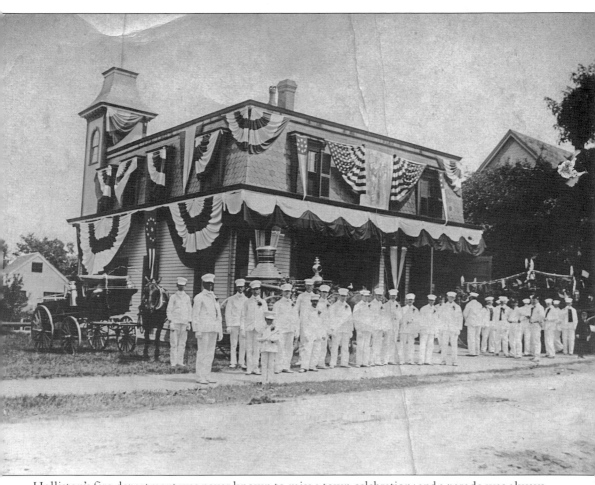

Holliston's fire department was never known to miss a town celebration, and a parade was always one great opportunity to show off their equipment. Here, firemen stand proudly in front of one of their two steam engines; both were purchased in the 1870s. The old fire station, located on Central Street just beyond the brook, was replaced in 1930 by the new Central Fire Station just a few fire hose lengths closer to the square. (DC.)

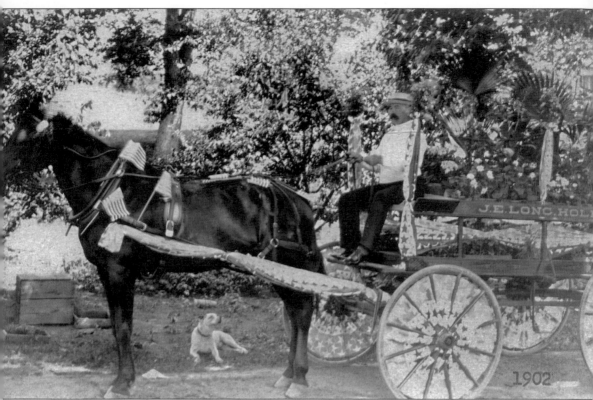

"For Heaven's sake get my Ad. out of your paper," wrote J.E. Long of Holliston to the *New England Florist* magazine in 1898. "I am sold out and overrun with orders!" It is comforting to know that business was booming in Holliston and that Long, a nurseryman and supplier to area florists from his greenhouses on Avon Street, could celebrate his prosperity by decorating his wagon for the Fourth of July parade in 1902. (DC.)

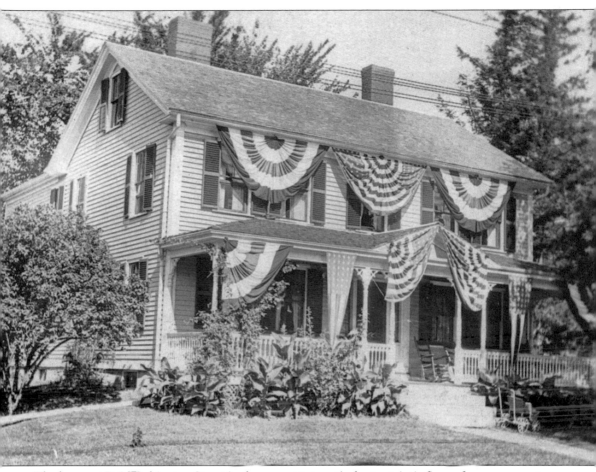

The house at 755 Washington Street in the square put on the best patriotic finery for many events that took place in Holliston The house has experienced many transformations, from a lawyer's office to gift a shop to its current use as the home of House at 755, a unique store located in the heart—and at the heart—of historic Holliston. (PG.)

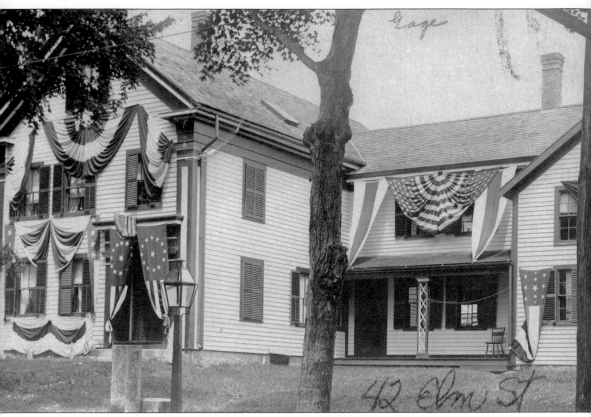

The large, rambling house at 42 Elm Street was located next to the old Mowry straw hat factory, along the nearby brook. Once used as a rooming house to accommodate the large number of female hat workers, the home was owned by Watson P. Gage, who never missed an opportunity to decorate the house for celebrations. (DC.)

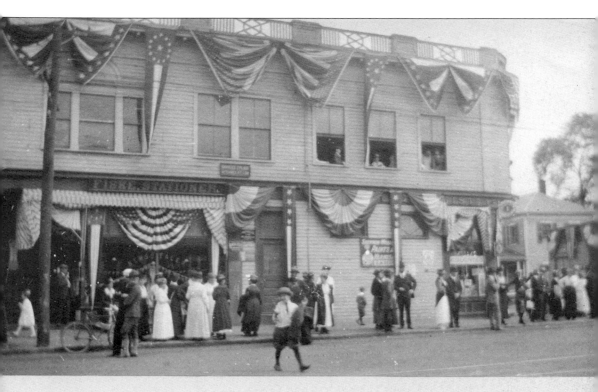

FISKE'S STORE WASHINGTON ST 1902

In 1902, the Fourth of July parade attracted spectators in front of Fiske's General Store while waiting for the festivities to begin. The square has been witness to countless parades and celebrations and still is today. No parade then or now would be complete without at least one pass along Washington Street. (DC.)

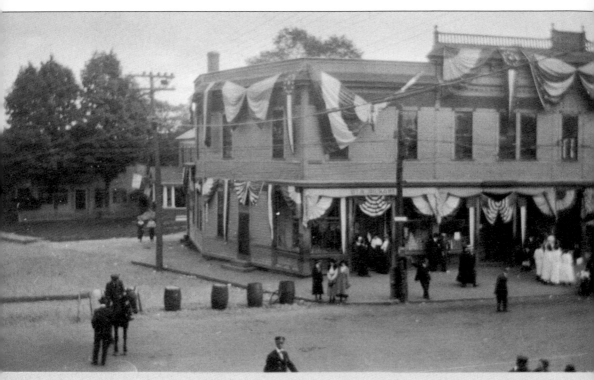

CORNER OF CENTRAL & WASHINGTON ST 1902

In 1902, the Fourth of July parade attracted spectators before the festivities began. With Central Street blocked off, the crowd waits for the parade to start. (DC.)

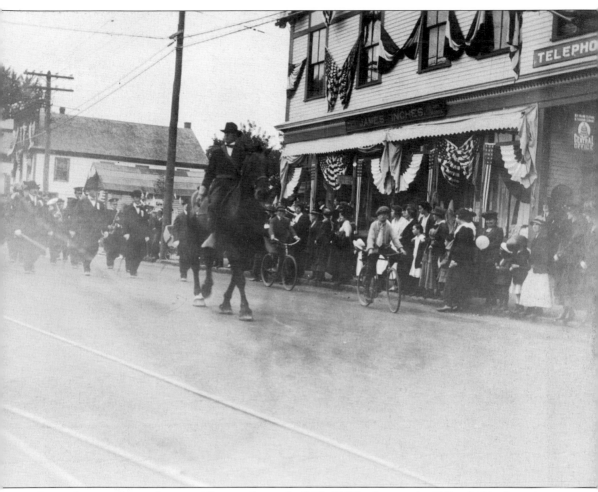

A parade to welcome home soldiers at the end of World War I passes by Talbot's Block on its way toward town hall. Crowds watch as the dignitaries pass by, and boys follow the course on bicycles, getting a closer glimpse of the action while keeping even with parade marshal Freeman Shippee. (PG.)

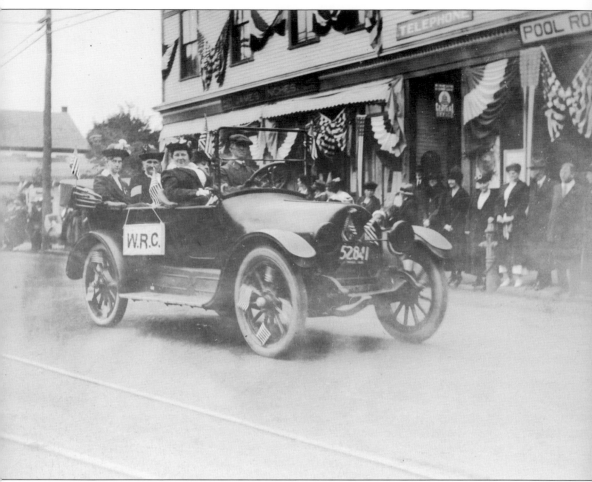

A dignified committee of the Woman's Relief Corps takes part in the welcome home parade held after World War I in 1919. Note there was actually a billiards hall in Holliston! The Woman's Relief Corps, an auxiliary unit to the Grand Army of the Republic founded in 1883, was an active organization associated with Holliston's Post No. 6 GAR. (PG.)

Eight

INDUSTRY

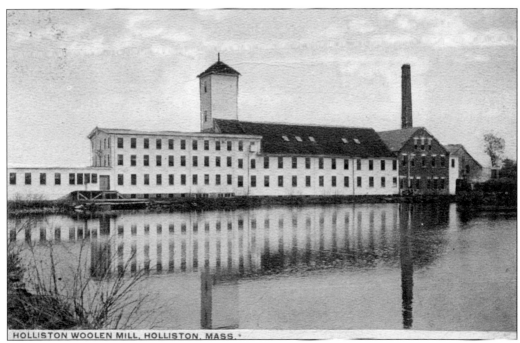

The Holliston Woolen Mill occupied the oldest industrial site in Holliston, Boggastow Brook, located near Woodland Street, and was first used for waterpower in the late 17th century to power a gristmill. As industry expanded, so did the factories at Mill Pond in size and importance. At the site, cotton thread was once produced. Woolen blankets also were woven here, and government contracts sometimes kept the looms running. (PG.)

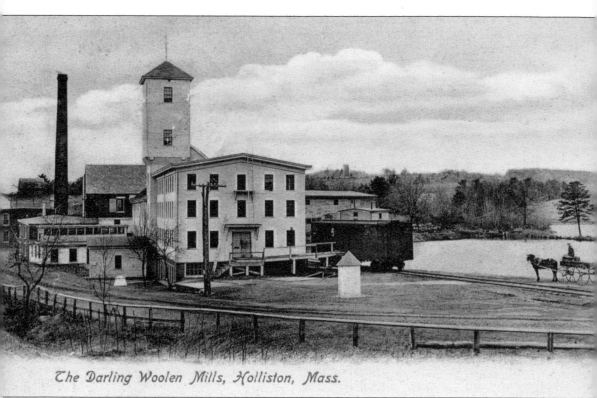

The Darling Woolen Mills, Holliston, Mass.

A.W. Darling of Worcester purchased the Winthrop Woolen Mills from Charles Dawson of Holden in 1902 and expanded the manufacture of woolen blankets. From then on, it was known as the Darling Woolen Mills. The amount of power that could be produced by Mill Pond severely limited the capacity of the Darling Woolen Mill, and the factory complex was not easily converted to more efficient ways to power it. (PG.)

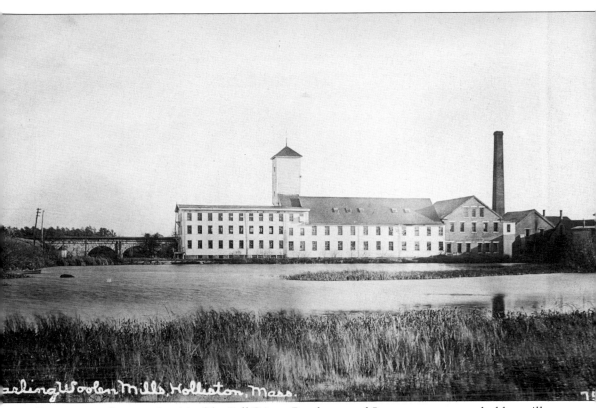

arling Woolen Mills, Holliston, Mass.

Larger manufacturers in cities like Fall River, Brockton, and Lynn soon surpassed older mills such as the Darling on Mill Pond. As workers sought jobs at larger factories, the factory fell into disuse and was shuttered up for good. Many workers found jobs at the Draper Mill in Hopedale and traveled there by hopping on the train that passed by daily over the eight-arch bridge that graced their former workplace. The abandoned buildings burned in 1933. The old smokestack hung around for a few more years but finally gave up and came crashing down in October 1949. (PG.)

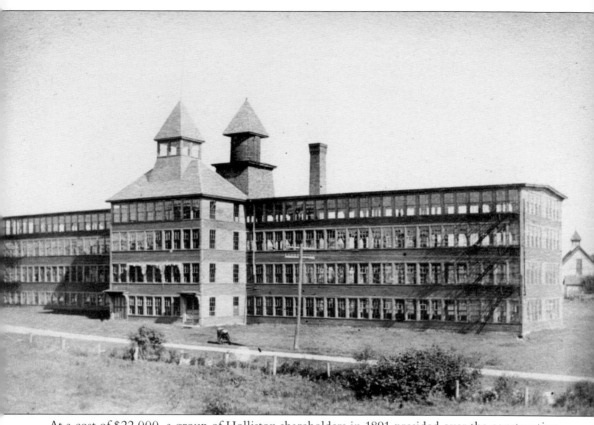

At a cost of $22,000, a group of Holliston shareholders in 1891 presided over the construction of a state-of-the-art factory on Water Street in order to attract new industry to Holliston. The stockholders who supported the construction of the shop were justly proud of the new building that was ready for immediate occupancy in November 1891. A grand opening gala was held on the top floor to celebrate the end of construction and allow the curious to have a look around. The building was advertised as having an open floor plan with no obstructive beams and as light and airy, and each worker would have a window in front of him in an effort to provide an improved working atmosphere. (PG.)

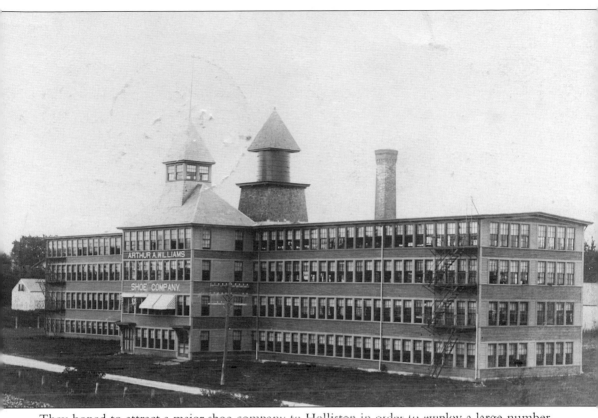

They hoped to attract a major shoe company to Holliston in order to employ a large number of workers who had once worked at Holliston's old shops that were now mostly obsolete by industry standards. At first, they were successful when the Beal Company of Brockton arrived. The company tried to succeed here, but in 18 months, it left abruptly, expressing its dismay at the high cost of fire insurance in Holliston. (DC.)

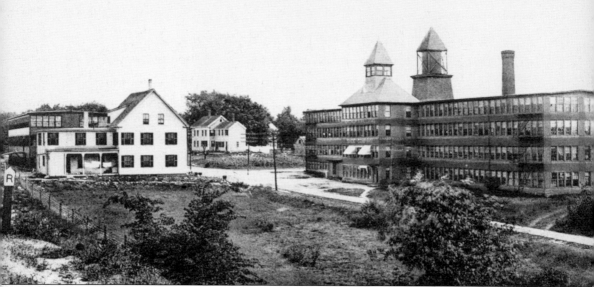

The complex remained underutilized until Arthur A. Williams of Cochituate arrived to save the day. John Clancy, a prominent shoe manufacturer in Holliston, had retired and was concerned about his workers being left without employment. John encouraged Arthur to move his factory to Holliston after Williams's Cochituate shop burned in 1908. The big shop on Water Street was ready and waiting for him. (PG.)

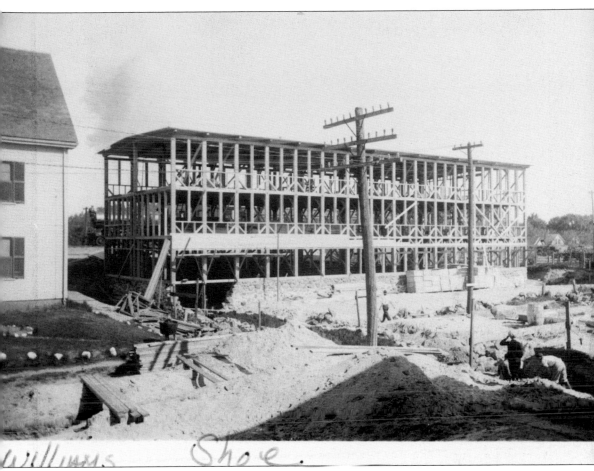

Williams Shoe.

Soon after Williams's arrival in Holliston, he expanded the complex by building the annex across the street. He also constructed a tunnel, seen here in this photograph, between the two buildings in order, it was rumored, to keep his patent secrets and new products safe from the prying eyes of industry rivals. Arthur Williams's Goodwill Shoe Company was a leading manufacturer of steel-toed boots, favored by workers involved in all kinds of heavy construction. His innovations live on in today's heavy-duty work boots now manufactured around the world. (DC.)

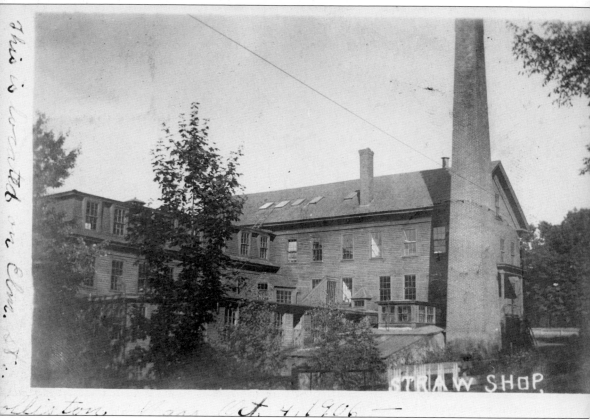

Holliston's second most important industry was the manufacture of straw hats, which were popular in the 19th century. The Daniel C. Mowry shop on Elm Street employed 200 men and women at the shop and many others who worked braiding straw at home to make hats sold in fashionable shops in Boston and New York. Trimmings such as peacock feathers and artificial flowers were imported from local suppliers as well as Europe, China, and Japan. Sales approached $200,000 yearly. (PG.)

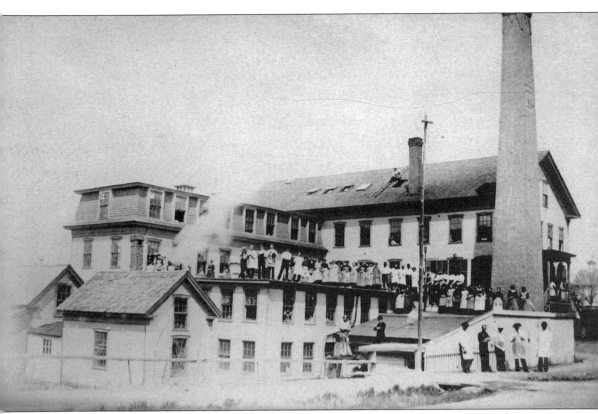

When times were good, there was work to keep 200 people busy within the factory and outside at homes where workers did braiding and piecework, returning the product to the main floor for finishing the hats. In September 1890, the Mowry shop was the site of Holliston's first labor strike when the straw machine girls protested a wage cut. They held out for two weeks. The work environment was certainly difficult to endure at times. During a heat wave in 1893, the temperature rose to 120 degrees inside the factory. (PG.)

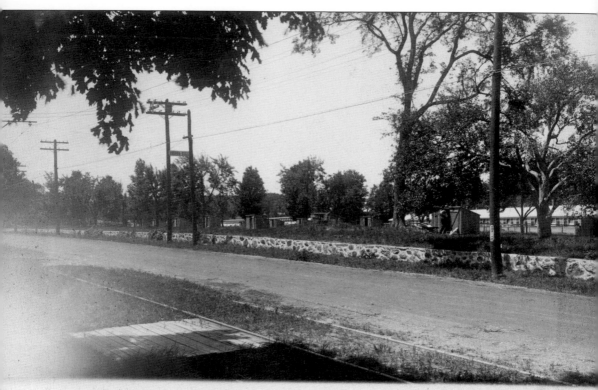

3723 Pittsfield Poultry Farm Co., (Capacity 175,000 Eggs),
Holliston, Mass.

The Pittsfield Poultry Farm Company of Pittsfield, Maine, purchased the farm on Phipps Hill formerly owned by Andrew J. Cass in 1913. The farm was converted into a poultry operation with 165 portable colony houses that would each accommodate 50 hens. Fancy and utility white Plymouth Rock hens were the preferred fowl. Incubating houses could hold 150,000 eggs at one time, and two brooder houses for 8,000 laying hens were constructed along Highland Street, the only two buildings that remain today. The Holliston operation, albeit briefly, became part of the largest egg manufacturing operation in the world. The company produced brown eggs. (PG.)

Nine

IT PAYS TO ADVERTISE

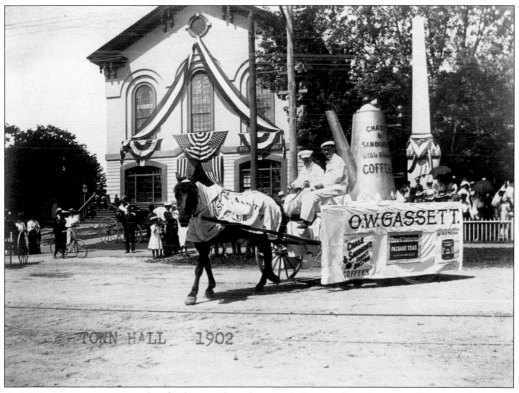

Otis W. Gassett, at a Fourth of July parade, advertised Case and Sanborn Coffee a product that was sold at his store in the square. Case and Sanborn Company of Boston, established in 1862, claimed to be the first coffee company to pack roasted coffee in sealed tins. (DC.)

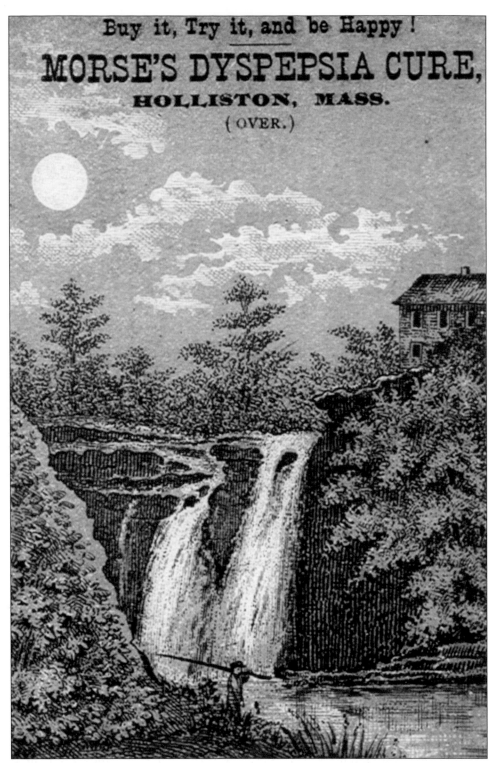

Cards advertising locally produced patent medicines were an early use of postcards. In 1886, druggist Charles H. Morse of Holliston vigorously promoted his cure for stomach ills. (DC.)

A New Discovery!

MORSE'S

DYSPEPSIA CURE,

CURES

Dyspepsia, Indigestion, Flatulence, Weak and Sour Stomach, Heartburn, Water Brash, Constipation or Costiveness, Bilious Colic, Loss of Appetite, Palpitation of the Heart, Sick Headache arising from a disordered Stomach

And all Bilious Complaints.

NO CURE, NO PAY.

I will cheerfully refund the money, if, after taking the third bottle, the patient is not satisfied. Its effect is rapidly seen after two or three days, and a cure always follows its use.

PRICE, 50 CENTS.
TRIAL BOTTLE, 10 CENTS.

Prepared only by the Proprietor,

C. H. MORSE, Holliston, Mass.

WEEKS & POTTER,
GEO. C. GOODWIN & CO., Wholesale Agts.
Boston, Mass.

SOLD BY ALL DRUGGISTS. Call for it, and take no other.

Morse was an aggressive promoter of his product. In 1886, he made the largest contribution to Holliston's baseball team and won the naming rights—Morses's Dyspepsia Baseball Club, also known as, mercifully, as the "MDCs." (DC.)

George Wellington Slocum was Holliston's first antique dealer. A supplier of feathers and other embellishments to fancy hat manufacturers by trade, an occupational inheritance from his father, Lewis, George was also enthralled with the theater and spent many nights attending plays in Boston. He met his wife, Abby, an actress and musician, and together they treated Holliston audiences to decades of great entertainment on the town hall stage. (DC.)

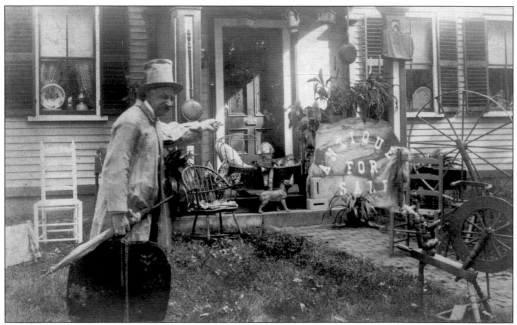

There was no scarcity of antiques and collectibles in Wellington's day. He was afforded a steady supply of treasures and junk cast off by friends, neighbors, and apparently, according to this advertising postcard he circulated, several ex-spinsters. (DC.)

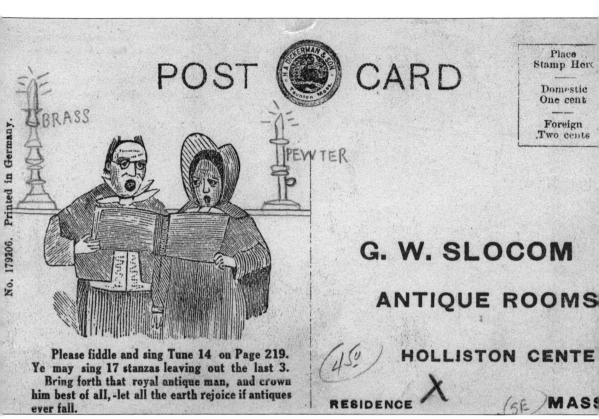

Within the image, the following text appears:

POST CARD

BRASS

PEWTER

Printed in Germany.

No. 179306.

H.A. DICKERMAN & SON, Taunton, Mass.

Place Stamp Here

Domestic One cent

Foreign Two cents

G. W. SLOCOM

ANTIQUE ROOMS

HOLLISTON CENTE[R]

RESIDENCE (5E) MASS

Please fiddle and sing Tune 14 on Page 219.
Ye may sing 17 stanzas leaving out the last 3.
Bring forth that royal antique man, and crown
him best of all,-let all the earth rejoice if antiques
ever fall.

Middlesex Bank on Washington Street now occupies the location of George W. Slocum's antique shop and residence. The location, just off the square, was a prime spot for a business. Patrons were just a few steps off the trolley cars from his house and lawn, which was routinely covered with new finds. Antique shops continue to flourish around the square, and the antique hunters of today owe George W. Slocum a tip of the hat for starting a long and enduring tradition in Holliston. (DC.)

Lavinia's Window

1763

Antiques

and

Gifts

Early

American

Pressed

Glass

HOLLISTON, MASS.

Opening Wed. Oct. 10 th
2 to 9 P. m.

GLADYS M. SMITH

MARY E. DUNCAN

TEL. HOLLISTON

202

Antique shops in Holliston have been around for longer than many may imagine. Lavinia's Window, located at 1727 Washington Street, occupied one of Holliston's oldest houses. Lavinia Newton, who was betrothed to Elihu Cutler, tested her diamond engagement ring by scratching her name on a windowpane, thus confirming Elihu's integrity and providing a fitting name for the shop. Lavinia married Elihu with confidence in 1798. (DC.)

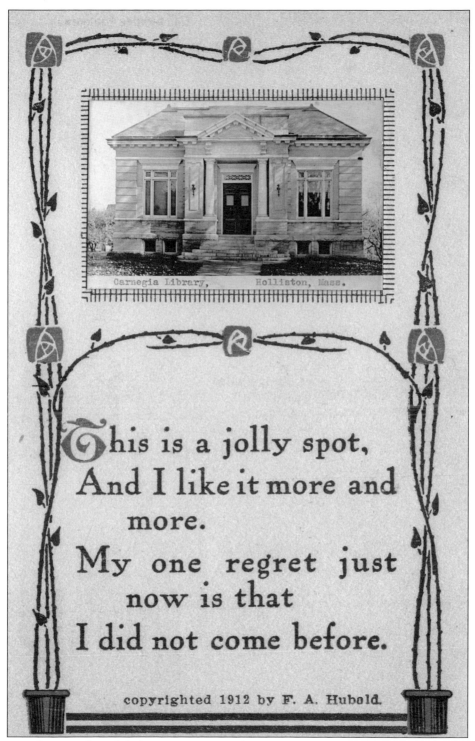

Carnegia Library, Holliston, Mass.

This is a jolly spot,
And I like it more and
more.
My one regret just
now is that
I did not come before.

copyrighted 1912 by F. A. Hubold.

Whimsical postcards with light verse were popular a century ago, and suppliers could add local interest with a small photograph to the card, combining artwork, poetry, and photography into an attractive bit of mail for the recipient. (DC.)

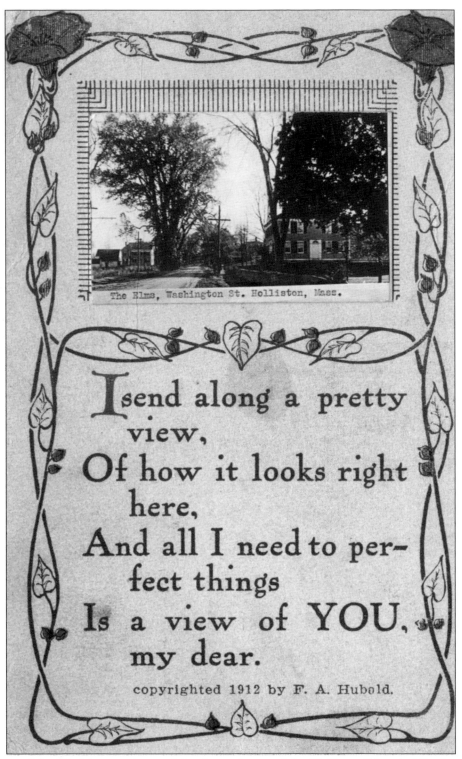

The Elms, Washington St. Holliston, Mass.

I send along a pretty view,
Of how it looks right here,
And all I need to per-
fect things
Is a view of YOU,
my dear.

copyrighted 1912 by F. A. Hubold.

A view of the Washington elms and the future home of the Holliston Historical Society was added as a local embellishment to a postcard artfully done. (DC.)

Greetings from Holliston, Mass.

A stock picture could be manufactured in large quantities, and all that was needed to give it a local touch was a line with greetings from anywhere. Could this be a scene from Holliston? Of course, and it could be from anywhere else too. (PG.)

AUCTION

AUCTION

150 COWS

MONDAY NOV. 3, 1952 AT 1:30 P. M.

50 FRESH COWS
100 SPRINGERS
(A REAL TOP LOT of DAIRY COWS)

SOME HEIFERS and STOCK BULLS

ALL T.B. and BLOOD TESTED

ANGUS McPHERSON
HOLLISTON, MASS.

RICHARD MURRAY, *Auctioneer* Terms: CASH

Angus McPherson operated a farm on Prentice Street. The golfers on Pinecrest Golf Club have replaced the cows that once grazed the fields along Highland and Prentice Streets. (DC.)

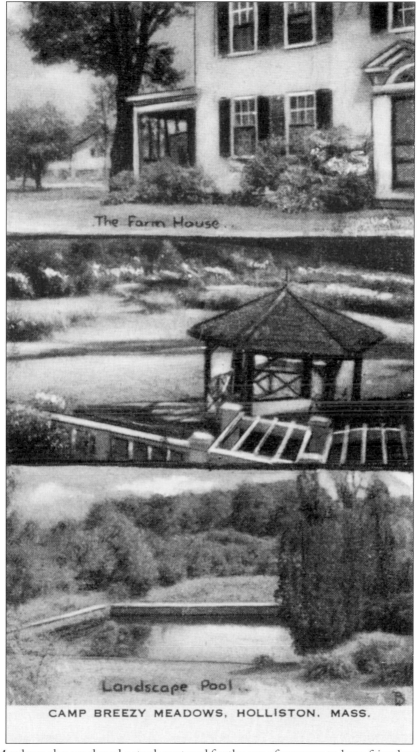

The Farm House..

Landscape Pool..

CAMP BREEZY MEADOWS, HOLLISTON. MASS.

Breezy Meadows also produced a stock postcard for the use of campers to keep friends and family updated about the great times they were having. (DC.)

Louis E.P. Smith, owner of Linda Vista, the picturesque farm on the slope of Phipps Hill, was the quintessential example of a gentleman farmer. He made his money selling insurance, but his heart was in farming, and he purchased Linda Vista, the home of his grandparents, and devoted himself wholeheartedly to agrarian living. (DC.)

Ten

AND FINALLY

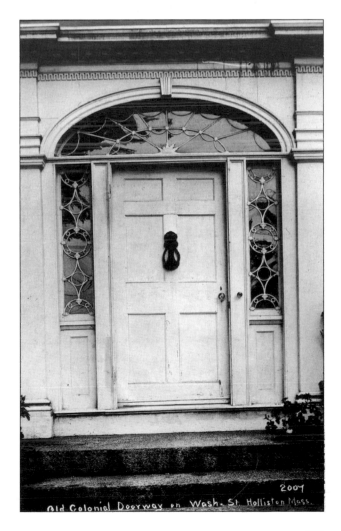

Between 1800 and 1820, an itinerant glazier sold this popular doorway to several Holliston homeowners. This door graces the Holliston Historical Society. Asa Whiting built the home in 1812. (PG.)

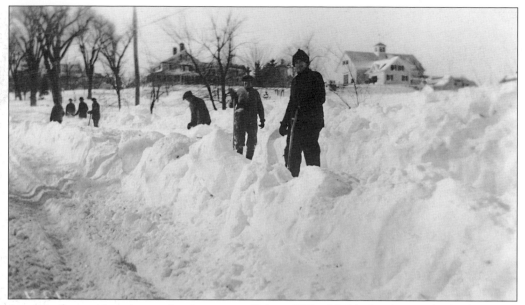

A crew of snow shovelers makes its way up Phipps Hill with Linda Vista in the background. Before motorized means of snow removal saved time and effort, much of the work was done either with cylindrical granite snow rollers dragged behind horse-drawn wagons or the time-honored way—by hand and shovel. (PG.)

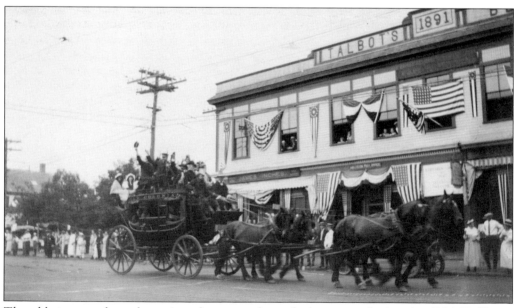

The old stagecoach made a triumphant pass through the square during the 1924 Holliston bicentennial celebration. Less than 10 years hence, Holliston will be celebrating three hundred years of history. It is time, perhaps, to start the search for a stagecoach and a driver. (PG.)